THEN & NOW

ROXBURY

Opposite: The New Roxbury Market was located at 2677 Washington Street and offered a wide selection of groceries and provisions as well as fresh fish and oysters, which could be taken or delivered by the horse-drawn wagon seen on the right. White aproned clerks, as well as a few curious neighborhood children, pose in front of the store about 1885. (Courtesy of Historic New England.)

ROXBURY

Anthony Mitchell Sammarco
Contemporary Photographs by
Charlie Rosenberg

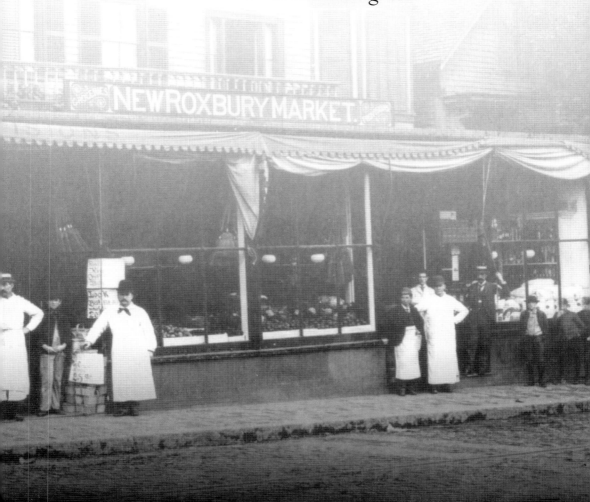

To the memory of the Reverend John Eliot (1604–1690),
"Apostle to the Indians," teacher, translator, and minister,
and his kinswoman Elizabeth Curtiss.

Copyright © 2007 by Anthony Mitchell Sammarco
ISBN 978-0-7385-4957-6

Library of Congress control number: 2006934444

Published by Arcadia Publishing
Charleston SC, Chicago IL, Portsmouth NH, San Francisco CA

Printed in the United States of America

For all general information contact Arcadia Publishing at:
Telephone 843-853-2070
Fax 843-853-0044
E-mail sales@arcadiapublishing.com
For customer service and orders:
Toll-Free 1-888-313-2665

Visit us on the Internet at www.arcadiapublishing.com

On the front cover: Please see page 91. (Vintage photograph courtesy of Frank Cheney, contemporary photograph by Charlie Rosenberg.)

On the back cover: Please see page 69. (Courtesy of Frank Cheney.)

CONTENTS

ACKNOWLEDGMENTS

I would like to thank Charlie Rosenberg for his insightful "Now" photographs.

I would also like to thank the following for their assistance in the researching and writing of this book: Boston Public Library, Print Room, Aaron Schmidt; Judith Reed Emmons Bullock; Alice F. Casey; Joe Cedrone; William F. Clark; Elizabeth Curtiss; the late Dexter; William Dillon; Olivia Grant Dybing; eBay; the late A. Bradlee Emmons; Forest Hills Educational Trust; Helen Hannon; Historic New England, Lorna Condon, Emily Novak, and Sally Hinckle; Stephen Kharfen; James Z. Kyprianos; Paul Leo; Barbara Drake Lobrano; Robert Murphy, West Roxbury Historical Society; Frank Norton; the residents of Orchard Cove, Canton, Massachusetts; Michael M. Parise; the perceptive Fran Perkins; Anthony and Mary Mitchell Sammarco; Rosemary Sammarco; the Dudley, Egleston, and Grove Hall branches, Boston Public Library; Roxbury Latin School; Ruggles Baptist Church, Margaret Dunn; Robert Bayard Severy; Sandra Spring; Erin Stone, my editor; Archives and Special Collections, Healey Library, University of Massachusetts Boston, Elizabeth Mock; the Urban College of Boston; the Victorian Society, New England Chapter; Casi and Steven Walker, South End Photo Lab; West Roxbury Historical Society, Robert Murphy; Susan Williams; and James Preston Wysong.

A portion of the royalties from this book will benefit the Archives and Special Collections, Healey Library, University of Massachusetts Boston.

INTRODUCTION

Roxbury is a historic neighborhood of the city of Boston, settled in 1630 by a group of Puritans seeking to establish a new community that extolled the virtues and freedom of religion they felt was lacking in England at that time. They named their new town Roxbury due to the prevalent outcroppings of rocky puddingstone that dotted the landscape and often made farming an arduous task. However, Roxbury also has a great claim to fame in that the first Bible to be printed in North America was translated from English into the Native American tongue in the town.

The Reverend John Eliot (1604–1690), a graduate of Oxford and settled minister of the Roxbury Meeting House from 1632 to 1690, became fluent in the native tongue of the Massachusetts Indians and translated the King James version of the Bible into their native tongue in 1663; the result was two generations of "Praying Indians," who heeded the word of the Christian God and who followed the teachings of Eliot and his followers. This occurrence was to bring great renown to the small settlement from throughout New England as well as England, and it is still remembered over three centuries later as an important example of the determination and benevolence of the Puritans who settled Massachusetts Bay Colony.

Throughout the first two centuries after its settlement, Roxbury was primarily an agrarian town with residences and shops along the early streets now known as Dudley, Centre, Roxbury, Warren, and Washington Streets and in Jamaica End and Westerly, which are today the Boston neighborhoods known as Jamaica Plain and West Roxbury. The town center has been at Meeting House Hill, now known as John Eliot Square, where the first meetinghouse was built in 1632. This measured pace in society was to change in the early 19th century with manufacturing becoming an increasingly important part of the economy. Clock making, tanneries, fruit orchards, a rubber factory, lithographers, building concerns, as well as the brewing of beer along the Stony Brook River, brought great prosperity and renown to Roxbury, and as a result, the population steadily increased to support these new industries. By the early 1820s, the town was serviced by an omnibus that ran hourly to Boston, and in 1835, the Boston and Providence Railroad was laid through Roxbury, providing additional development. The ease of transportation allowed residents of Roxbury the mobility necessary to commute to Boston, and by the beginning of the 20th century, Roxbury was a web of streetcar lines that connected it to all parts of the city.

The annexation of Roxbury to the City of Boston in 1867 (effective January 6, 1868) was an important factor in its development. A city in its own right since 1846, it now became a neighborhood of Boston and was to be known as Boston Highlands. During the period between 1868 and 1900, new streets were laid out by the city and numerous houses were built as the population increased steadily. From what was basically a Yankee town prior to the Civil War, the diversity became evident with immigrants arriving from

western Europe, most notably from Ireland and Germany. As the character of the town was changing, members of old Roxbury families sought to preserve the history of the town, and resident Charles Mayo Ellis (1818–1878) authored the *History of Roxbury Town* in 1847. However, it was Francis S. Drake (1828–1885), who in 1878 authored *The Town of Roxbury: Its Memorable Persons and Places*, that we owe so much to for preserving the history of the period from 1630 to 1878. The farmland that had been so prevalent for two centuries had given way to estates of the wealthy merchants and was subdivided into urban streetscapes that allowed a diverse population. From developments such as Harriswood Crescent, a group of 15 row houses designed by J. Williams Beal and built in 1889 on Harold Street, the former Horatio Harris estate, to apartment buildings and three deckers being built throughout the neighborhood, the convenient, well placed location attracted people from a wide spectrum of society, creating a thriving nexus of cultures. By the early 20th century, Roxbury's Jewish community extended from Grove Hall to Mattapan, along Blue Hill Avenue with numerous temples being built. By the middle of the century, migration of African Americans from the South saw many settling in Roxbury, so much so that by the early 1970s, the neighborhood was primarily black. Today Roxbury has a wide spectrum of residents, of all socioeconomic standings, races, ethnicities, and religions. Historical personages such as Dr. Joseph Warren, patriot of the Revolution; Charles Dana Gibson, originator of the Gibson girl; John L. Sullivan, famous boxer; and Charles Follen Adams, author, have been joined by Jonathan Kozol, activist; Malcolm X, black nationalist; Louis Farrakhan, head of the Nation of Islam; and Bobby Brown, musician, as people who called Roxbury home. It truly is the face of a cosmopolitan city, and continues to evolve with each and every resident adding to the fabric that weaves together the history of this fascinating community.

The rocky outcroppings of glacial deposits throughout Roxbury have come to be known as "Roxbury puddingstone." They were used for retaining walls, residences, and churches and were immortalized by Oliver Wendell Holmes in his poem, "The Dorchester Giant" in his inimitable humor. He said that a giant of old gave his wife and children a pudding stuffed with plums, which, in their rage, they flung over all the country: "Giant and mammoth have passed away, / For ages have floated by; / The suet is hard as marrow-bone, / And every plum is turned to a stone, / But there the puddings lie. / And if some pleasant afternoon, / You'll ask me out for a ride, / The whole of the story I will tell, / And you shall see where the pudding fell / And pay for the punch beside."

ROXBURY

INSTITUTIONS

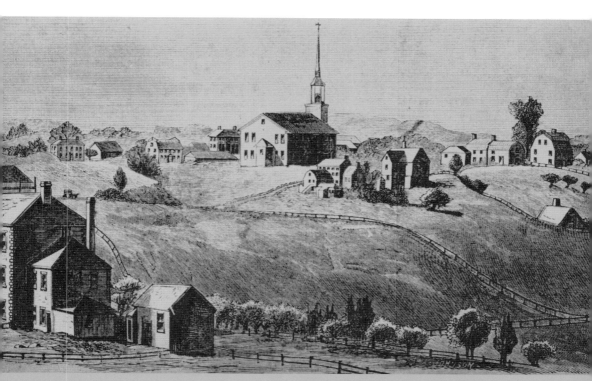

Roxbury Meeting House Hill, seen in an etching from a 1790 painting by John Ritto Penniman (1782–1841), has been the center of Old Roxbury since it was settled in 1630. Meeting House Hill was surrounded by small farms and, although closely situated to Boston via the Neck, present day Washington Street, would remain rural well into the 19th century, after which farms were subdivided for estates and industry. (Author's collection.)

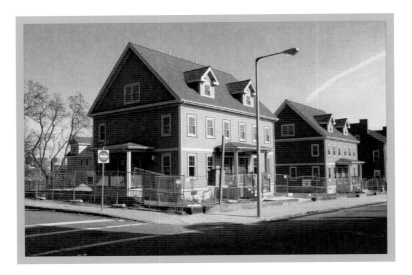

Roxbury Town Hall was designed by noted architect Asher Benjamin (1773–1845) and built in 1811 at the corner of Dudley and Putnam Streets. A two-story Federal building with an elegant belfry surmounting the facade pediment, it was to replace the meeting house for town affairs after the separation of church and state, and it later served as city hall. The second floor was used by the Norfolk Guards as their armory. After Roxbury was annexed to the City of Boston in 1867, the former town-city hall was demolished in 1873 and the Dudley Grammar School was built on the site. Today attractive wood-frame houses are being built on the site. (Author's collection.)

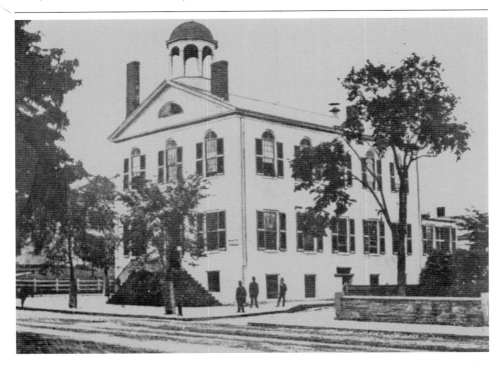

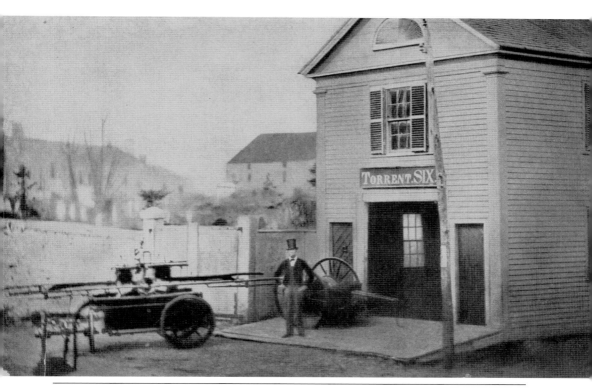

Torrent Six was a small wood-framed Greek Revival engine house built in 1829 and located at 20 Eustis Street, adjacent to the Eustis Street Burial Ground seen on the left. Standing by the hand-pump, horse-drawn fire engine in front is William Cooper Hunneman (1769–1856), a brass founder and member of the family that produced steam and chemical fire engines in mid-19th-century Roxbury. Today there is an abandoned redbrick and granite-trim Italianate fire station on the site, built in 1859 and designed by architect John Roulestone Hall. (Author's collection.)

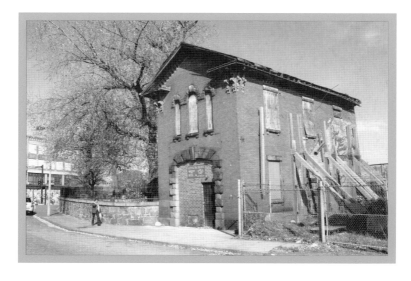

The Cochituate Stand Pipe was designed by Nathaniel J. Bradlee (1829–1888) and built in 1869 on Fort Hill to store water and pump it to houses in Roxbury. Built on the site of the Roxbury High Fort, a prominent Revolutionary War eminence, it can still be seen from miles around due to its lofty prominence. In 1895, Olmstead Associates was commissioned by the City of Boston to design the surrounding park and stonewall embankment, and in 1906, the tower was converted to an observatory when Roxbury was connected to city water. (Courtesy of Boston Public Library.)

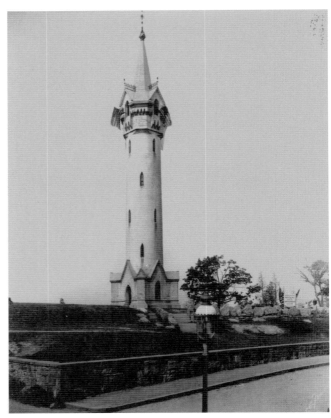

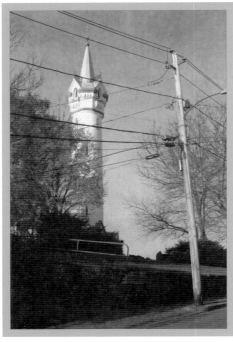

The Roxbury Court House was at 90 Roxbury Street near Dudley Square. An impressive buff brick and limestone Georgian Revival structure with a rusticated first floor supporting a pediment and Ionic pilastered facade, it would later be replaced by a modern edifice at 10 Malcolm X Boulevard, which is a gateway from Dudley Square to Roxbury Crossing. (Courtesy of Historic New England.)

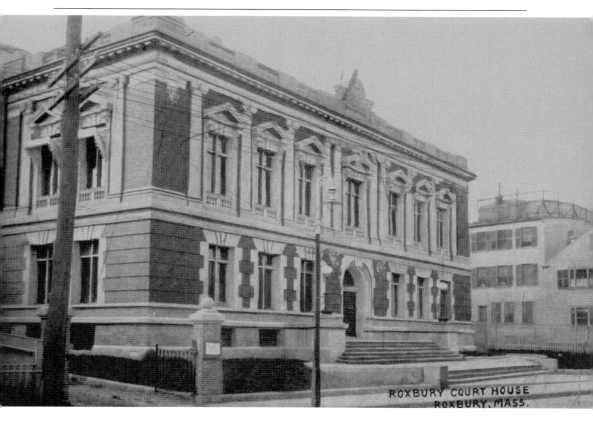

ROXBURY COURT HOUSE
ROXBURY, MASS.

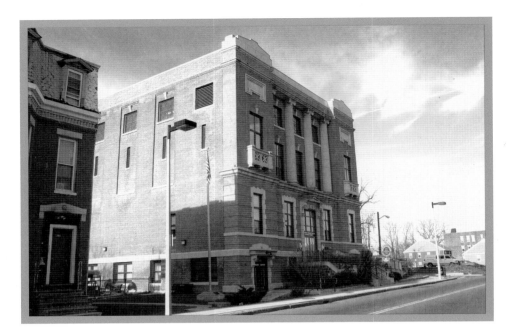

The Roxbury Municipal Building was built at the corner of Dudley Street and Mount Pleasant Avenue. At the beginning of the 20th century, the City of Boston began an expansion of city offices for the neighborhoods, building municipal offices throughout the annexed towns. This redbrick and limestone municipal building is an elegant, classical revival structure that included office space, a gymnasium, and a meeting hall for concerned residents. Today this is the Vine Street Community Center. (Courtesy of Boston Public Library.)

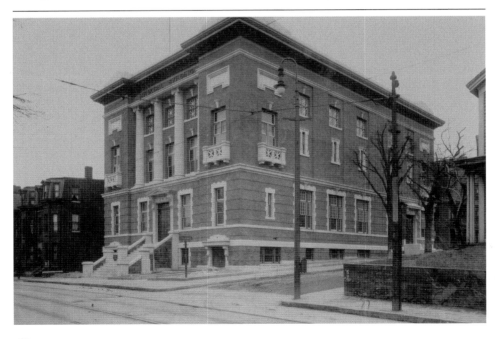

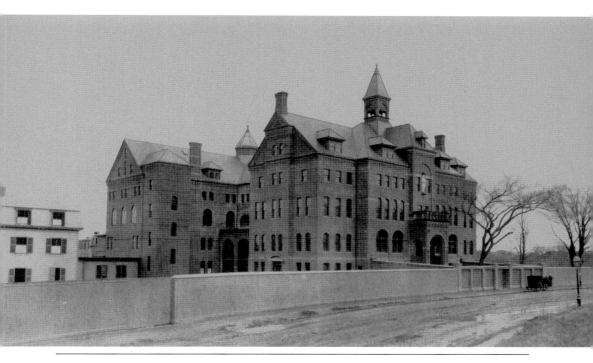

The House of the Good Shepard was established in 1867 and was located at 841 Huntington Avenue, opposite Parker Hill Avenue. Founded by Bishop Williams of Boston, its object was "to provide a refuge for the reformation of fallen women and girls." Managed by the Sisters of the Good Shepard, it had provision for 150 girls and women, of all creeds and denominations, with shelter, food and employment, instruction in religion, good morals, and reading and writing being offered. Today the property has been developed with mixed high-rise and townhouse housing for Harvard University, and a portion of the gates still survives. (Courtesy of Historic New England.)

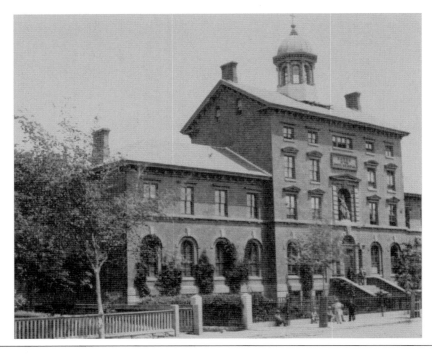

The House of the Angel Guardian was at 85 Vernon Street. Established by Rev. George F. Haskins as a Roman Catholic institution in 1851, its chief object was "to care for wayward boys, orphans, and destitute children." Its graded school system drew boarders who were educated in English and commercial and mathematical departments and eventually places were obtained for them so "they may learn trades or methods of business, or with farmers." The impressive three-story building was surmounted by an octagonal cupola with flanking wings. (Courtesy of Historic New England.)

Hibernian Hall is at 184 Dudley Street and was designed by Joseph M. Dolan and Edward T. P. Graham, two well-known architects. Built in 1913 for the Hibernian Building Association of Roxbury, it was a lively and popular social club and dance hall. Once the site of numerous Irish American functions, hence the name, it has been the Roxbury Center for the Arts at Hibernian Hall since 2005. (Courtesy of Historic New England.)

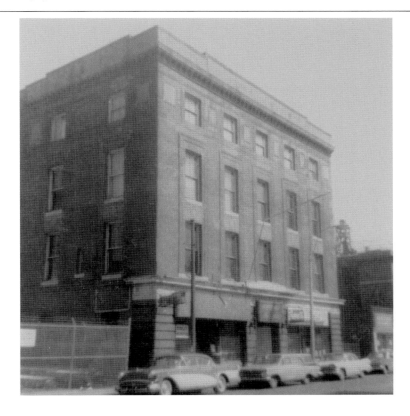

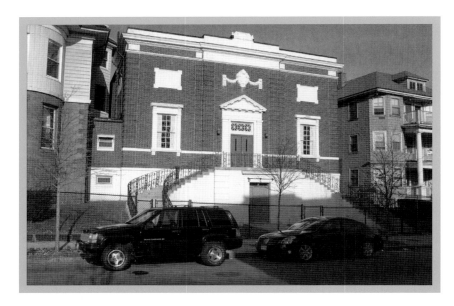

The gymnasium of the Young Men's Hebrew Association (YMHA) is on Humboldt Avenue, near Seaver Street. The YMHA moved to Roxbury in 1911 from the South End. It was a prominent institution until 1960 when the property was sold to the Seventh Day Adventist Church, and the YMHA merged with Hecht House. In 1970, it was closed and sold to the Lena Park Housing Development Corporation. Today the former gymnasium is part of the Berea Seventh Day Adventist Church. (Courtesy of Historic New England.)

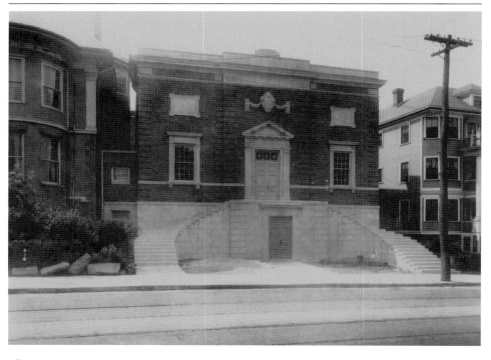

CHAPTER 2

PLACES OF WORSHIP

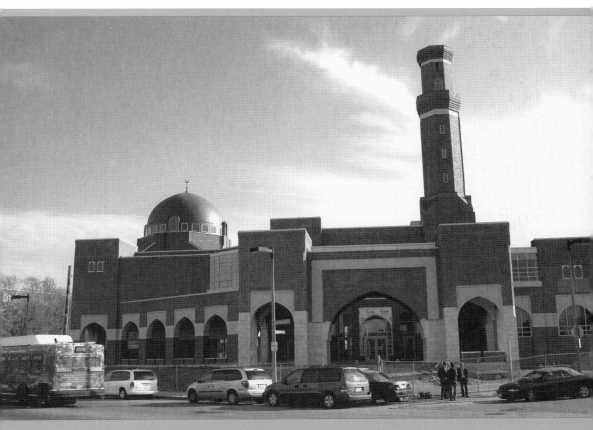

The Mosque for the Praising of Allah, designed by Steffian Bradley Architects, faces northeast to Mecca and is an enormous Arabic-style-inspired structure with 125 foot minarets at Roxbury Crossing, adjacent to Roxbury Community College. The Islamic Society of Boston broke ground in 2002 at the corner of Tremont Street and Malcolm X Boulevard for a facility that will accommodate hundreds of men and women in prayer rooms, an Islamic school for students up to the fifth grade, and a library. (Photograph by Charlie Rosenberg.)

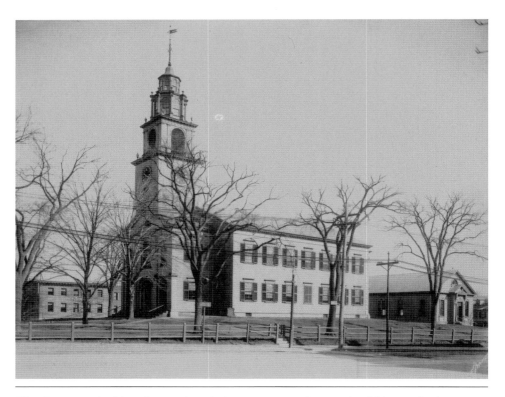

The First Parish Church was founded in 1631 and has been a prominent landmark on Meeting House Hill since the town was settled and built its first place of worship in 1632. Located in John Eliot Square, named for the Reverend John Eliot known as the "Apostle to the Indians," the present meeting house, the fifth, was built in 1804 and was designed by William Blaney. The spire has a bell cast by Paul Revere and Son. Since 1980, the Unitarian Universalist Congregation, First Church in Roxbury has worshipped here. (Courtesy of Boston Public Library.)

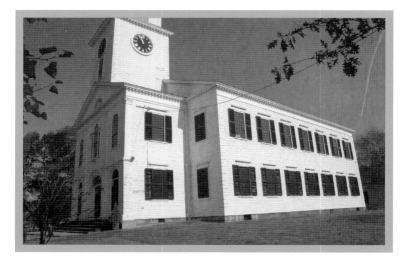

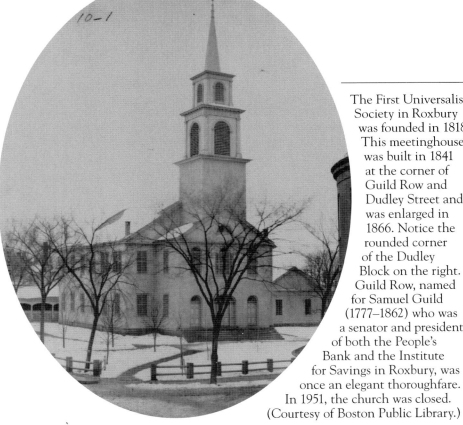

The First Universalist Society in Roxbury was founded in 1818. This meetinghouse was built in 1841 at the corner of Guild Row and Dudley Street and was enlarged in 1866. Notice the rounded corner of the Dudley Block on the right. Guild Row, named for Samuel Guild (1777–1862) who was a senator and president of both the People's Bank and the Institute for Savings in Roxbury, was once an elegant thoroughfare. In 1951, the church was closed. (Courtesy of Boston Public Library.)

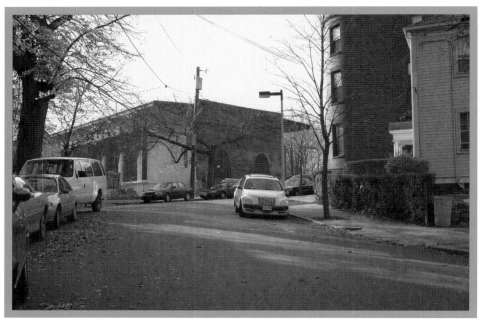

The Eliot
Congregational
Church, founded in
1834, was built in
1835 on Kenilworth
Street as an offshoot
of First Church.
The elegant spire
was added in 1847,
as the congregation
had increased
tremendously. On the
far left, the chapel
and vestry of the
church can be seen.
In 1922, the church
merged with the
Immanuel-Walnut
Avenue Church. The
church was destroyed
by fire in 1953, and the
Christ Temple Church
of Personal Experience
was built on the site.
(Courtesy of Historic
New England.)

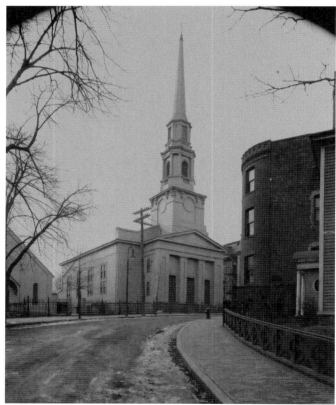

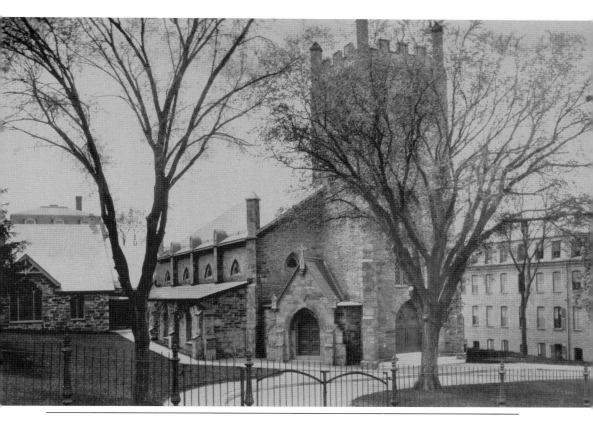

St. James Episcopal Church was founded in 1832 and two years later built this church on St. James Street near Washington Street. Designed by the noted architect Richard Upjohn, the popular Roxbury puddingstone was used for the Gothic-style exterior. The crenellated tower and lancet shaped windows made for an impressive place of worship. (Courtesy of Boston Public Library.)

The Dudley Street Baptist Church, founded in 1821, was at 137 Dudley Street, near Warren Street, and the church seen here was dedicated in 1853. A pointed, Gothic-style church, it was covered with mastic and blocked off in an imitation of solid brown sandstone and had a soaring 200 foot tower and steeple. In 1967, the church merged with the Centre Street Baptist Church in Jamaica Plain, which is now known as the United Baptist Church. (Courtesy of Historic New England.)

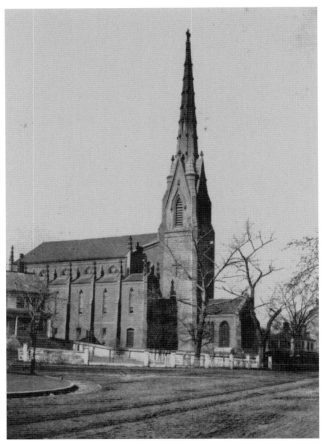

The First Methodist Episcopal Church was at the corner of Warren Street and Kearsage Avenue, and the spire and rear of the church can be seen rising above the Kearsage Avenue Burial Ground, which was later removed by Roxbury Latin School for use as a playing field. Today the Resurrection Lutheran Church worships on the site of the church, and the Boston Day and Evening School, formerly the Horace Mann-Phillis Wheatley School, is on the site of the former burying ground. (Courtesy of Historic New England.)

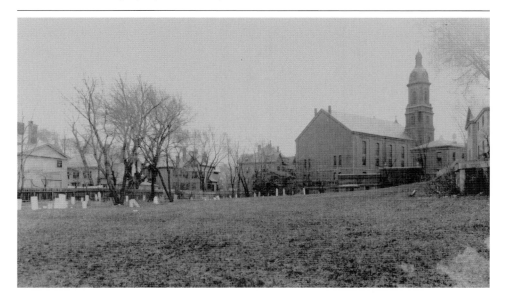

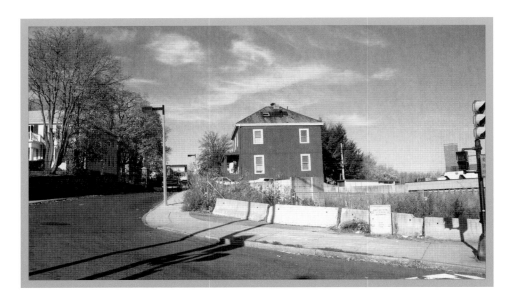

The Church of the New Jerusalem, Boston Highlands Society, was built in 1873 at the junction of Warren, Regent, and St. James Streets. The church was founded in 1870 as a Swedenborgian church, whose motto was "All religion has relation to life, and the life of religion is to do good." Built of Roxbury puddingstone, the church became the Church of God in Christ in 1959 and was eventually demolished in 1985. (Courtesy of Historic New England.)

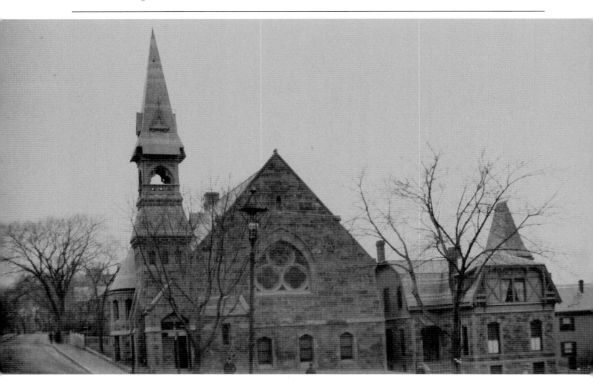

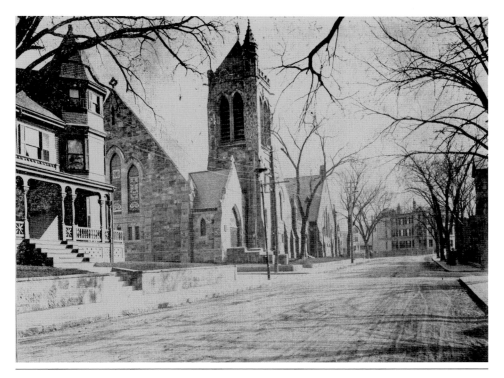

The Walnut Avenue Congregational Church, designed by J. Williams Beal and L. E. Giddigns, was founded in 1870 as an offshoot of the Eliot Congregational Church. The impressive Gothic-style church of Roxbury puddingstone with Nova Scotia stone trimmings was built in 1873 at the corner of Walnut Avenue and Dale Street. Today the Eliot Church of Roxbury worships here. (Courtesy of William Dillon.)

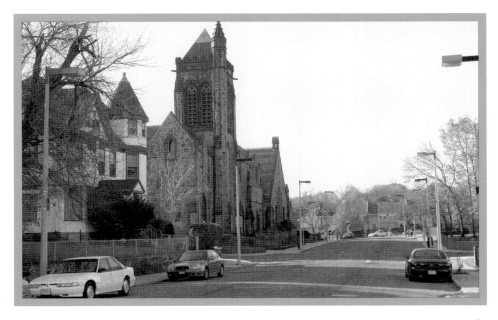

The Advent Christian Church, with the Advent Christian Publication Society occupying a street level shop, was at 144 Warren Street. Originally built in 1869 by the Boston Highlands Methodist Episcopal Church, the congregation later moved to Four Corners in Dorchester and renamed their church the Greenwood Memorial Church. Today the Second African Meeting House, on the left, and the Twelfth Baptist Church worship here in a drastically altered perma-stone exterior. (Courtesy of Historic New England.)

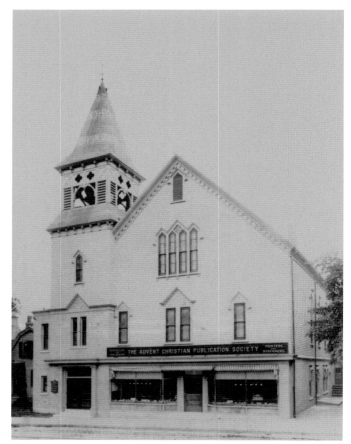

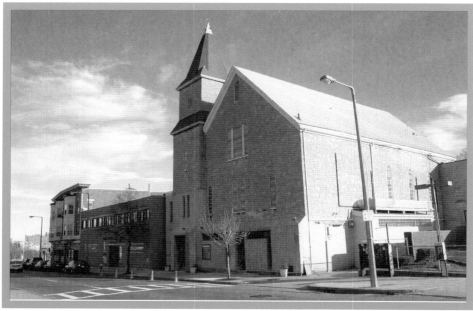

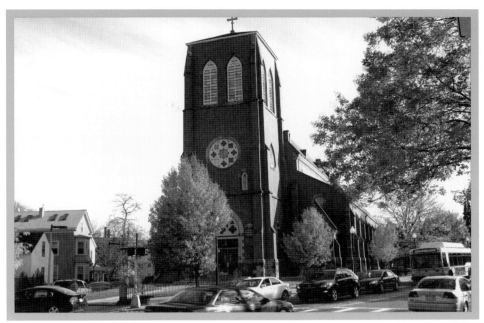

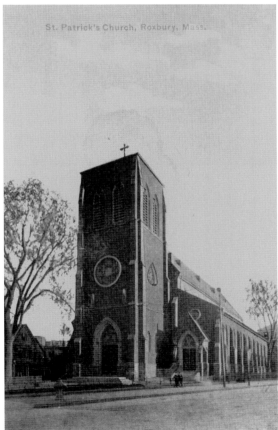

St. Patrick's Church, Roxbury, Mass.

St. Patrick's Church was founded in 1872, and dedicated to the patron saint of Ireland. Land was purchased in 1871 and the redbrick, Italianate church was built at the junction of Dudley and Dunmore Streets, opposite Blue Hill Avenue, and is the third Roman Catholic parish in Roxbury. Dedicated in 1880, it has served generations of Catholics in Roxbury. (Author's collection.)

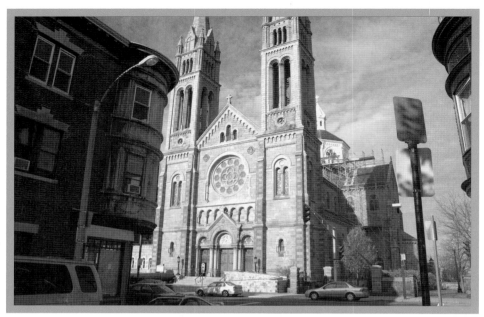

The Mission Church, officially known as the Basilica of Our Lady of Perpetual Help, was designed by Schickel and Ditmars and is an impressive church on Tremont Street near St. Alphonsus Street. Built in 1877 of Roxbury puddingstone and Quincy granite in the Romanesque style, it was to have monumental twin towers designed by Franz Joseph Unteresee built in 1910 to flank the entrance. On the left can be seen the Parochial Residence, built in 1902 on the site of Datchet House, the former Brinley-Dearborn estate. (Author's collection.)

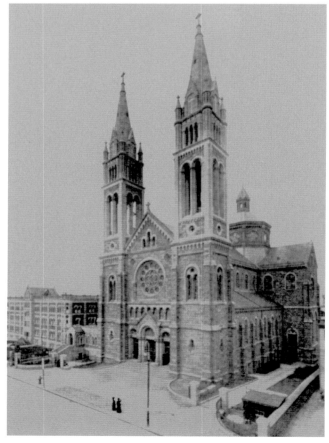

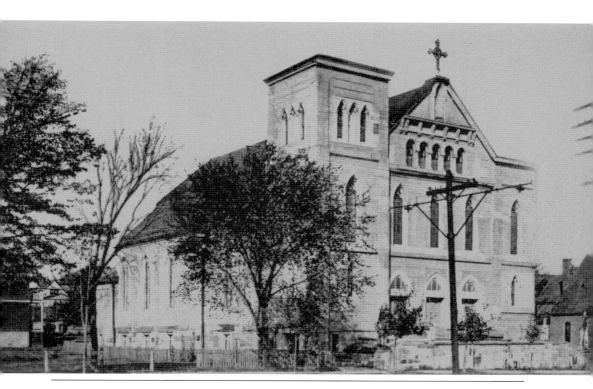

St. Hugh's Church was built in 1903 at 517 Blue Hill Avenue. It was constructed of reused granite from the Masonic temple at the corner of Tremont and Boylston Streets in Boston, which had recently been demolished. Today the church is known as St. John-St. Hugh Church. (Author's collection.)

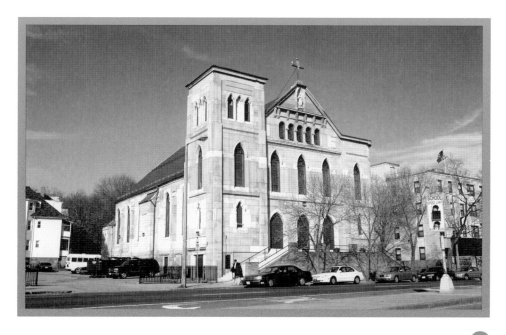

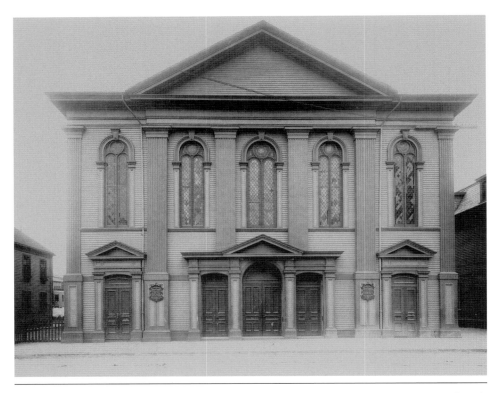

The Ruggles Street Baptist Church was organized in 1870 from the Branch Chapel Mission and the Ruggles Street Baptist Mission. This wood, Romanesque Revival church on Ruggles Street was destroyed by fire in 1925, and a new stone church was built, being used until 1970 when the congregation moved to Audubon Circle in Boston's Fenway. (Courtesy of Ruggles Baptist Church.)

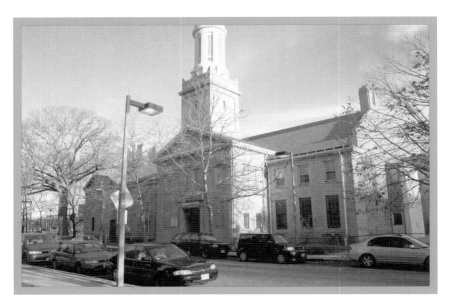

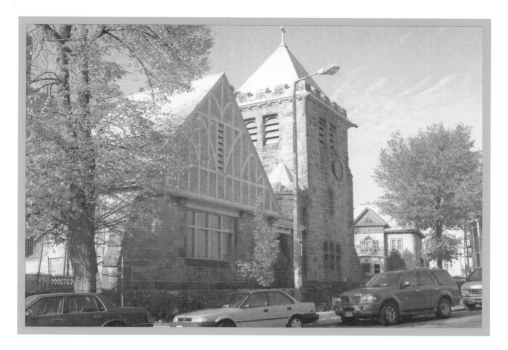

All Souls' Unitarian Church was designed by J. Williams Beal and built in 1888 at the corner of Warren Street and Elm Hill Avenue. Founded in 1846, it was once known as the Mount Pleasant Congregational Church and was originally at Dudley and Greenville Streets. In 1923, All Souls' was dissolved. Today the Charles Street African Methodist Church, which was founded in 1833 and had once worshipped in the Charles Street Meeting House on Beacon Hill, worships here. (Author's collection.)

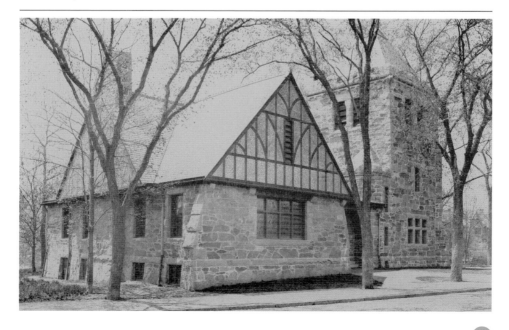

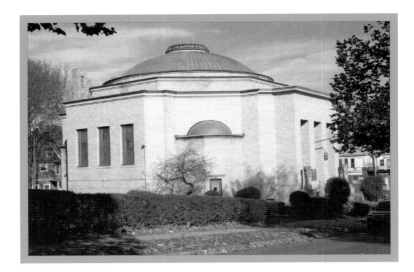

The Second Church of Christ Scientist is at the corner of Elm Hill Avenue and Howland Street. Designed by Shepley, Rutan and Coolidge and built in 1914, the church is an impressive Egyptian Revival design of buff brick with a huge dome and an impressive corner site. Today the church is undergoing restoration under the Steeples Project of Historic Boston. (Author's collection.)

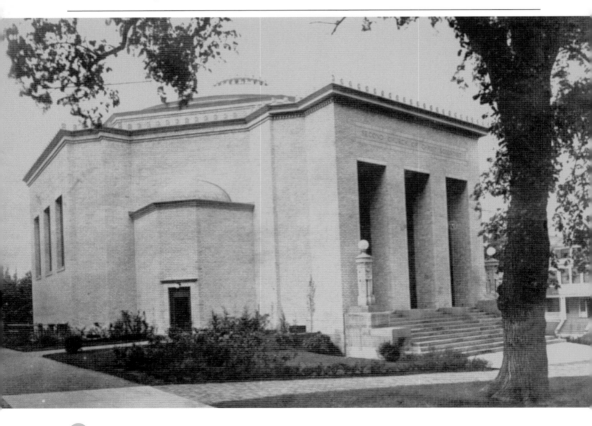

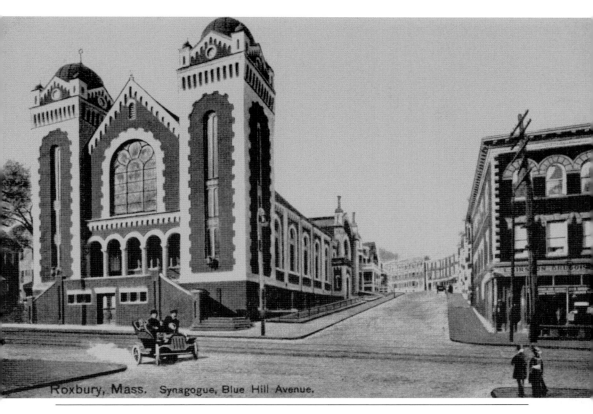

Roxbury, Mass. Synagogue, Blue Hill Avenue.

Adath Jeshurun was designed by architects David Krokyn and Frederick Norcross, and built in 1905 at 397 Blue Hill Avenue near Grove Hall. An impressive Romanesque Revival temple with twin towers flanking the entrance, it was later sold in 1967 to Ecclesia Apostolic. Since 1978 it has been the First Haitian Baptist Church, and has begun a restoration, most notably the founders' tablets on the facade, which memorialize those who built the temple. (Author's collection.)

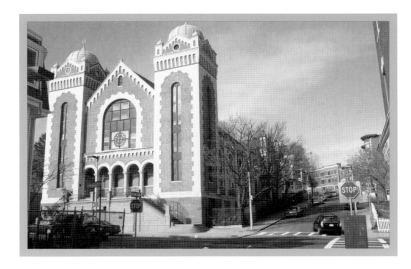

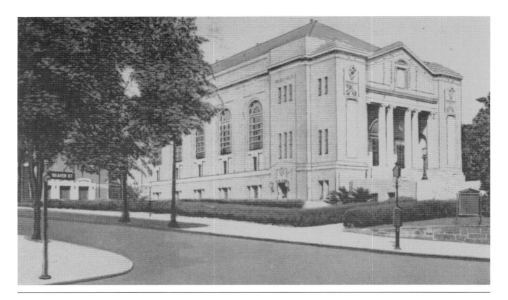

Temple Mishkan Tefila was founded in 1895 in Roxbury, and this temple was built in 1925 at the corner of Seaver Street and Elm Hill Avenue, overlooking Franklin Park. In 1968, the Elma Lewis School on Fine Arts occupied the former temple and allowed it to deteriorate. Today the United House of Prayer for All People worships here in a magnificently remodeled structure. (Courtesy of Sammarco Collection, Archives and Special Collections, Healy Library, University of Massachusetts.)

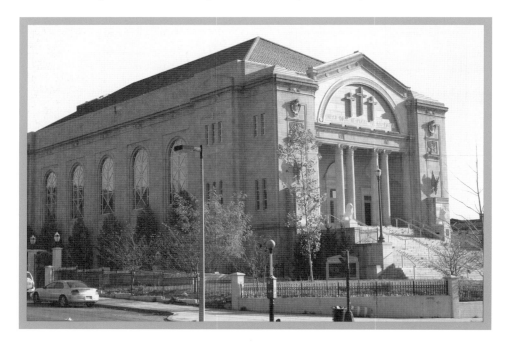

CHAPTER 3

SCHOOLS

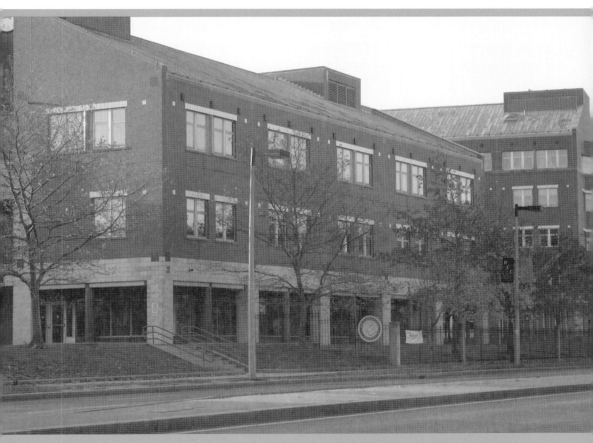

Roxbury Community College, designed by Stull and Lee Incorporated, was founded in 1973 and offers quality post-secondary higher education and strives to serve "communities with predominantly minority and recent immigrant populations." Once located in the former Ofgant-Jackson Chevrolet Dealership at Grove Hall, since 1988 its location is the impressive urban campus at 1234 Columbus Avenue, at the corner of Malcolm X Boulevard at Roxbury Crossing is, according to their logo, Where Futures Begin.

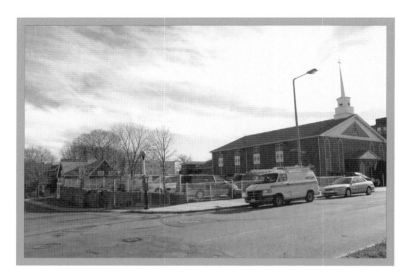

Roxbury High School was jointly designed by Charles J. Bateman and Harrison H. Atwood (1883–1954), successively City Architects of Boston. Built in 1885 at the corner of Warren and Montrose Streets, the high school was a massive Romanesque Revival redbrick and brownstone school with a soaring clock tower that could be seen along Warren Street. The school later became the Boston Clerical School and was demolished in 1976. (Author's collection.)

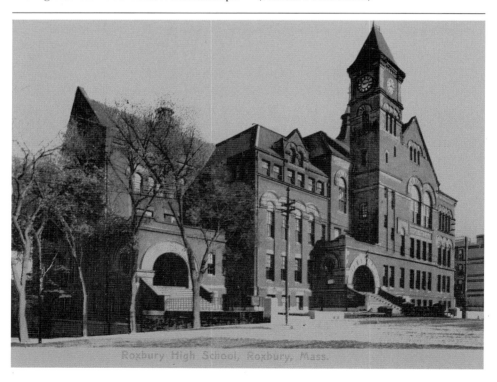

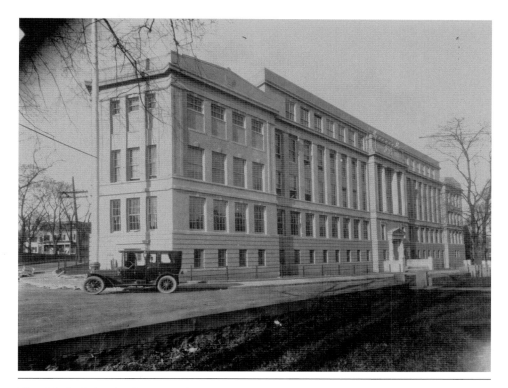

The High School of Practical Arts was built in 1914 at the corner of Winthrop and Greenville Streets and was modeled on the premise of training girls for practical arts, rather than a college course. (Courtesy of Historic New England.)

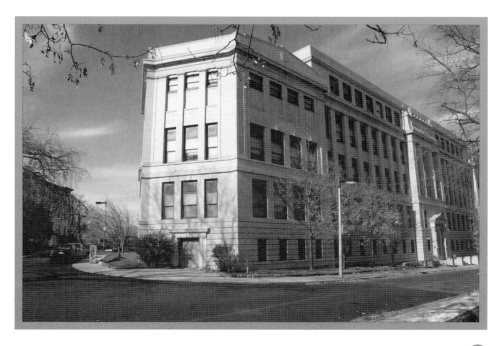

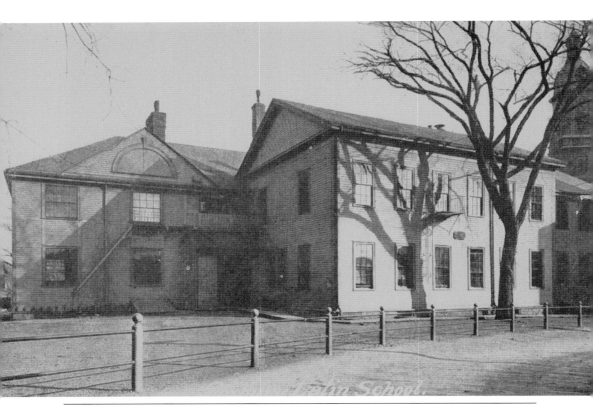

Roxbury Latin School was founded in 1645 and is the oldest preparatory school in the United States. Its purpose was to fit boys for "public service both in church and Commonwealth in succeeding ages" as well as being a feeder school to Harvard College, founded in 1636. Seen here, the small building was on Mount Warren Avenue, later known as Kearsage Street. Today the school is located on the former Codman Estate in West Roxbury. (Author's collection.)

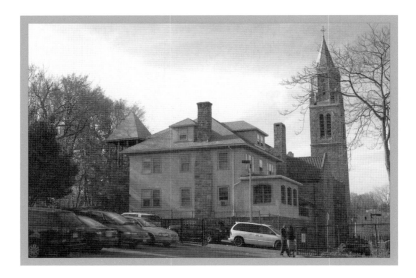

The Weston School for Girls was at 37–43 St. James Street and was a private day and boarding school for young ladies who were fitted "for life as well as examinations." Located in two large Victorian mansions, the school was administered by Elizabeth Mathews-Richardson, who was prominent in educational circles and whose school was "different, better and worth investigating," according to an advertisement of the period. (Author's collection.)

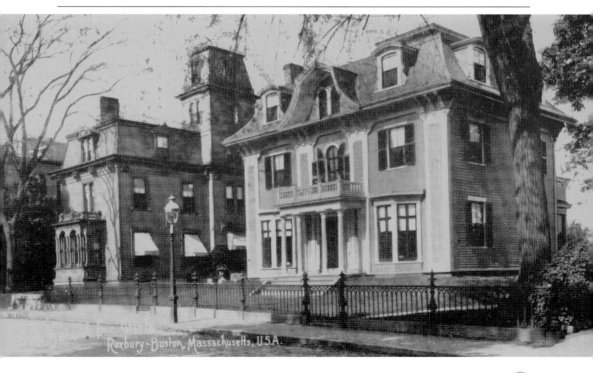

Roxbury~Boston, Massachusetts, U.S.A.

The Elm Hill School, with Fauntleroy Hall, was founded in 1887 by Alice Collar Davis and was at 42 Wenonah Street. The long, low, shingle-style school was designed by Boston architect Edwin J. Lewis Jr. (1859–1937) and provided intermediate, general, and college preparatory courses as well as fitting boys for the Roxbury Latin School until 1915. It was said that "every effort is made to arouse ambition and a love of study, but by such means that the school life may be happy and fruitful." (Courtesy of Historic New England.)

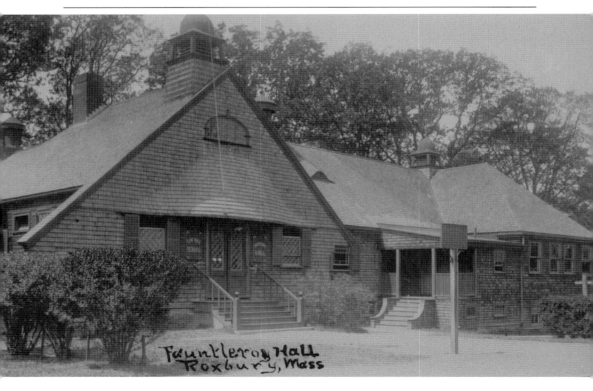

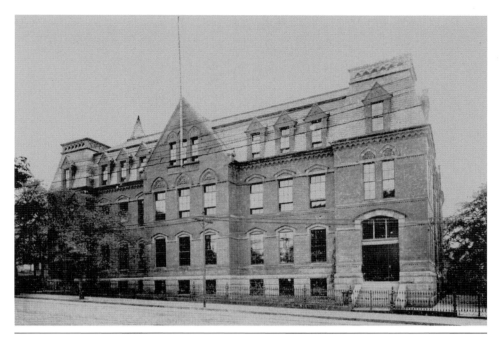

The Dudley School was built in 1873 at the corner of Dudley and Putnam Streets on the site of the former Roxbury Town-City Hall. The elementary school was named for the prominent Dudley family, which included Gov. Thomas Dudley (1576–1653), Gov. Joseph Dudley (1647–1723), and Chief Justice Paul Dudley (1676–1751). Today new houses are being built on the site. (Author's collection.)

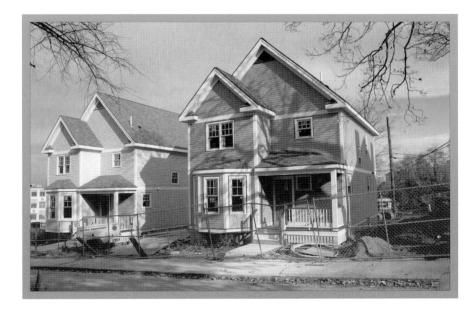

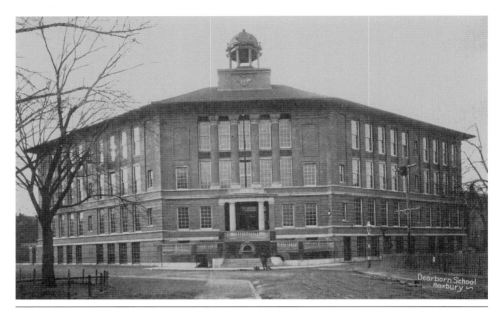

The Dearborn School, designed by Edwin J. Lewis Jr. and built in 1906, is at the corner of Orchard Park and Chadwick Street. The school was named for Henry A. S. Dearborn (1783–1851), mayor of the city of Roxbury from 1847 to 1851 and senator and collector of the Port of Boston. His estate, known as Datchet House, was on the present site of the Mission church. Dearborn was the first president of the Massachusetts Horticultural Society, and in 1848, was the originator of the bucolic Forest Hills Cemetery. (Author's collection.)

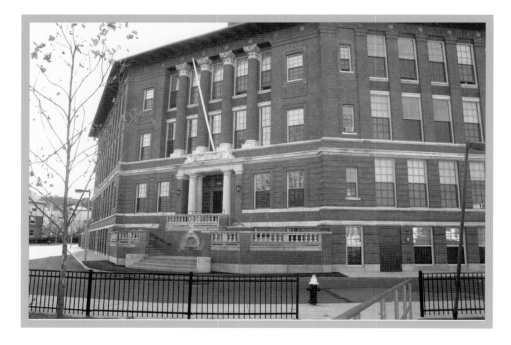

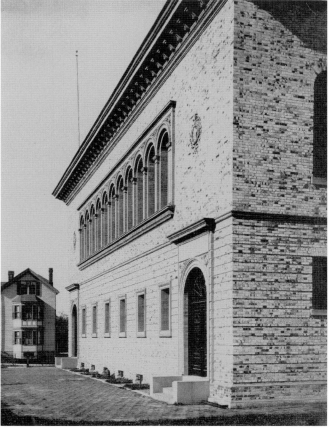

The Williams School was designed by Boston city architect Edmund March Wheelwright (1854–1912) and built in 1896 at the corner of Homestead and Harold Streets as an elementary school. The school was named for the Williams family, an old and prolific Roxbury family and benefactors of the local schools and charities. The locally famous Williams apple was hybridized in Roxbury. (Author's collection.)

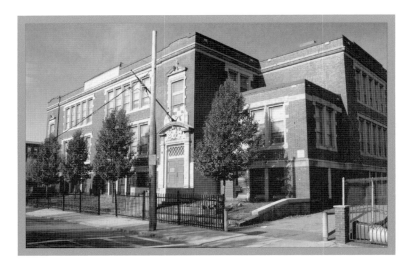

The Ralph W. Emerson School, designed by Mulhall and Holmes and built in 1924, is at 6 Shirley Street. The school was named for Ralph Waldo Emerson (1803–1882), the great author, transcendentalist, and "thinker for a changing America." An ordained minister, he called for American intellectual independence from Europe and often had his writings published in numerous well respected journals. Among his books were *Compensation*, *Self Reliance*, and *The Over Soul*. (Courtesy of Historic New England.)

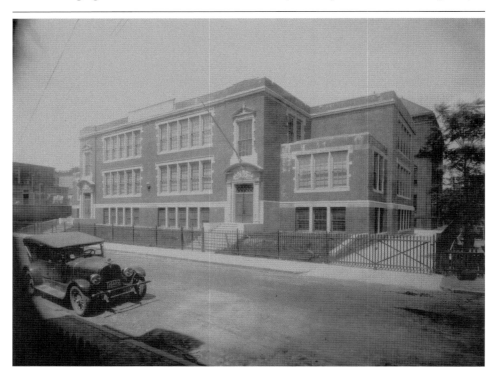

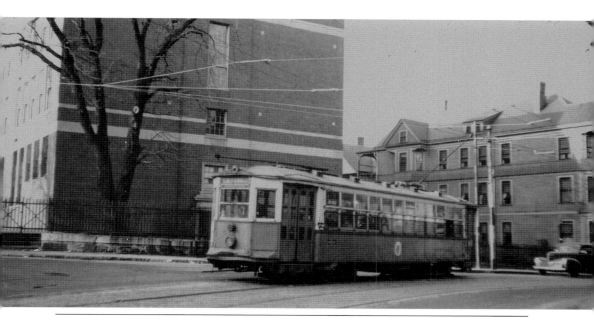

The George A. Lewis Middle School, designed by Harrison H. Atwood, was built in 1911 on Paulding Street, but backs up to Humboldt Avenue at the curve of Walnut Avenue. Here a streetcar passes the school in 1943. George A. Lewis was the last mayor of Roxbury, serving from 1863 to 1867, after which the city was annexed to Boston, effective January 4, 1870. (Courtesy of Frank Cheney.)

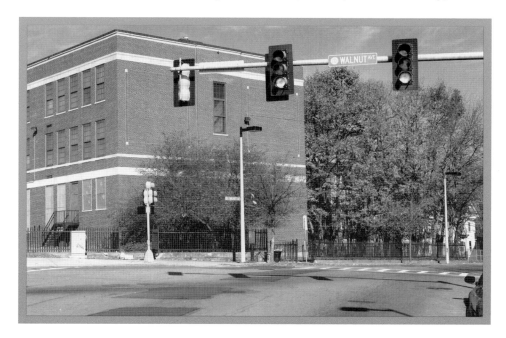

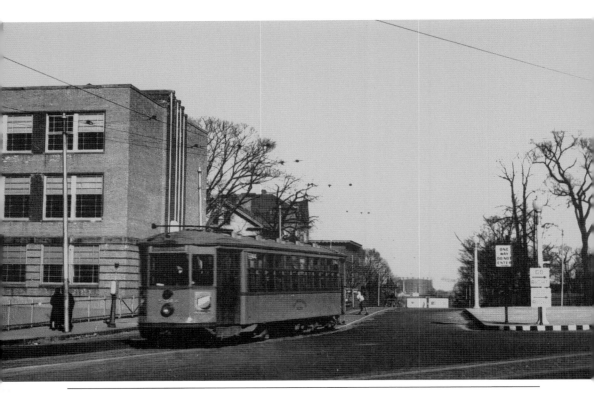

The James P. Timilty Middle School, designed by M. A. Dyer Company and built in 1937, is at 205 Roxbury Street, facing Eliot Square. A redbrick, severely art deco–style middle school of sixth, seventh, and eighth grades, it is notable in the Project Promise program, where the school day was extended and class size reduced, all of which led to the U.S. Department of Education's National Blue Ribbon Award for Excellence. (Author's collection.)

GROVE HALL, ALONG THE AVENUE

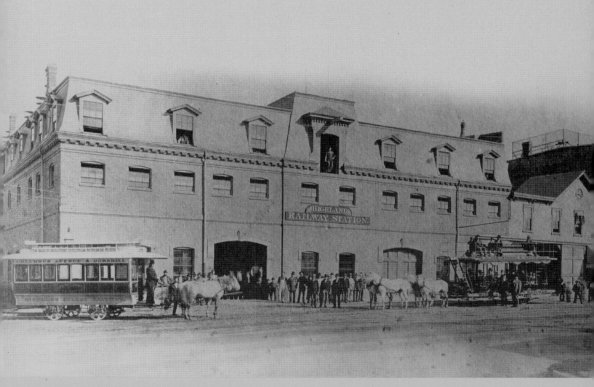

The Highland Railway Station, seen in 1881, was on Blue Hill Avenue, near Geneva Avenue, in Grove Hall. Built in 1872, the car house was a massive redbrick and mansard roof building that had space for both the streetcars as well as a stable for the horses. On the right is a double-deck open horsecar used from Oakland Gardens, near Franklin Park, to Temple Place in Boston. The Highland Railway Station gave way to the Ofgant-Jackson Chevrolet Dealership, which was later the first home of Roxbury Community College in 1973. Since 2000, it has been the site of the Grove Hall Mecca. (Courtesy of Frank Cheney.)

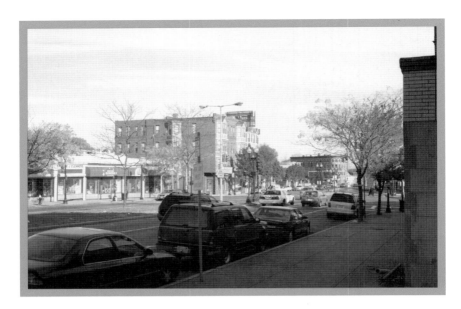

Looking east along Blue Hill Avenue to the junction with Warren Street in 1888, the Highland Railway Station can be seen on the right of the historic image, and shops on the left include the Ladies and Gents Dining Room, the E. W. Jordan Grocery Store, and the J. C. Pineo Grocery Store. In 1864, Dr. Charles Cullis founded the Cullis Consumptive Home at the junction of Washington Street and Blue Hill Avenue as a hospital for incurables. Today on the right is the Grove Hall Mecca and the Unity Plaza. (Courtesy of William Dillon.)

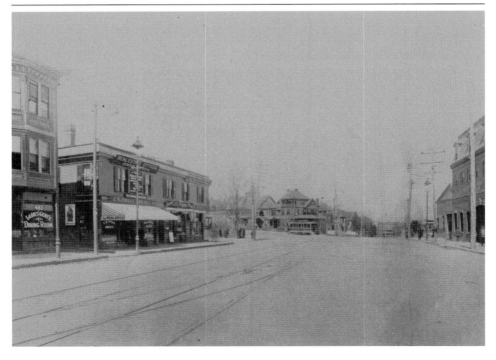

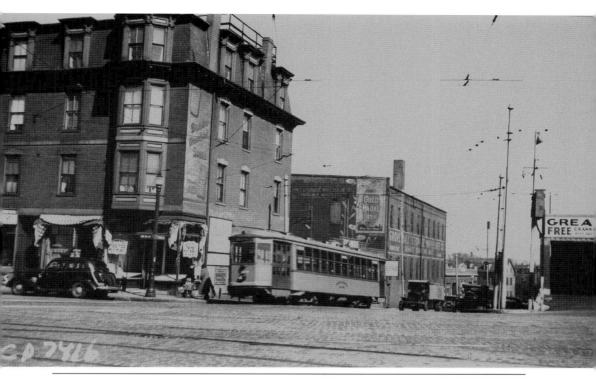

Streetcar No. 5928 approaches Blue Hill Avenue from Geneva Avenue in 1938. On the first floor of the redbrick building at the corner in the historic image is the Grove Hall Kosher Meat Market, as the neighborhood was the home to thousands of Jews in the 1900–1950 period. Seen in the distance is the Grove Hall Storage Warehouse Company. (Courtesy of Frank Cheney.)

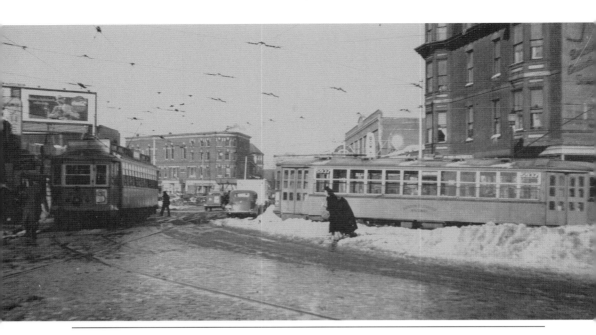

Streetcar No. 5287, on the left, and streetcar No. 5937 are at the intersection of Blue Hill and Geneva Avenues in February 1940. Laid out in 1876, Geneva Avenue extends from Blue Hill Avenue to Park Street and is a major connector to Dorchester. Two women emerge from a snow bank trying to cross Blue Hill Avenue, a busy intersection for well over a century. (Courtesy of Frank Cheney.)

Streetcar No. 5942 is seen in Grove Hall, the junction of Blue Hill and Geneva Avenues and Washington and Warren Streets, in 1932. The tall apartment building on the left was built in 1887; on the right is a small wood-framed car house, built in 1874, next to the Ofgant-Jackson Chevrolet Dealership, and today the site of the Grove Hall Mecca. (Courtesy of Frank Cheney.)

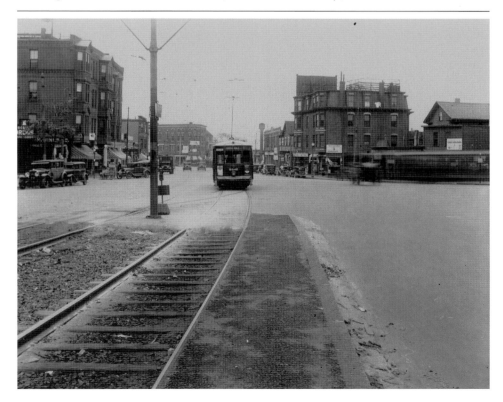

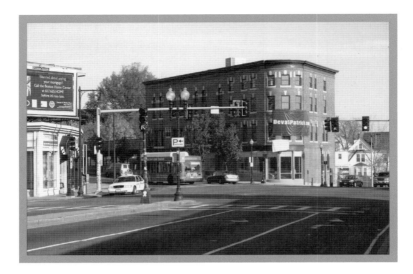

The Grove Hall Building is a four-story, redbrick and cement commercial block that commands the corner of Warren Street and Blue Hill Avenue. Grove Hall was named for the estate of Thomas Kilby Jones (1759–1842), an auctioneer and wealthy merchant whose home was built in 1800 at the junction of Washington Street and Blue Hill Avenue, now the site of Ma Dixon's Restaurant. (Courtesy of Frank Cheney.)

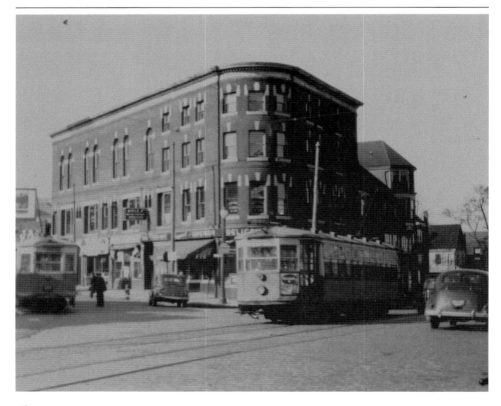

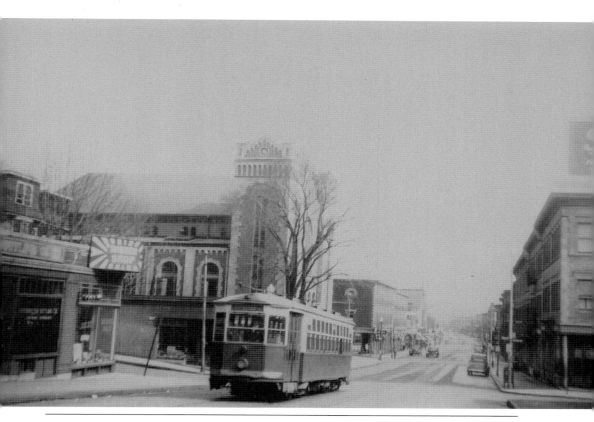

Streetcar No. 5927 is at the corner of Blue Hill Avenue and Devon Street in 1947. Devon Street was laid out in 1880. In the distance the impressive Temple Adath Jeshurun, which was designed by architects Frederick Norcross and David Krokyn, and built at 397 Blue Hill Avenue at the corner of Brunswick Street, can be seen. Today the former temple is the First Haitian Baptist Church. (Courtesy of Frank Cheney.)

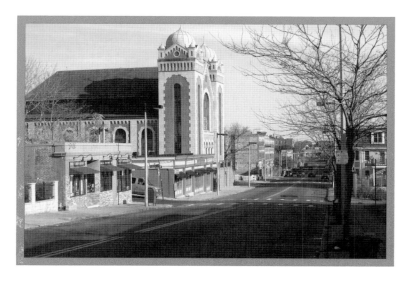

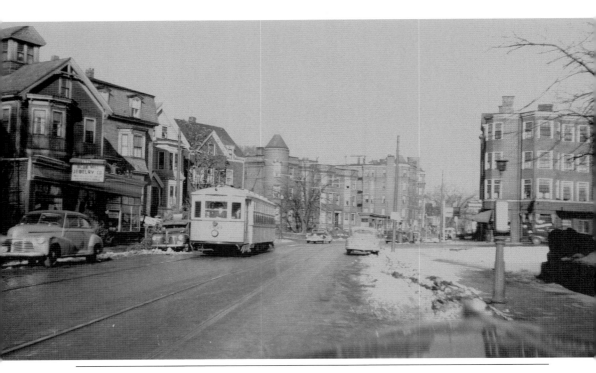

Streetcar No. 5621 is at the corner of Blue Hill Avenue and East Cottage Street in 1948. East Cottage Street was laid out in 1893 and connects Blue Hill Avenue to Columbia Road, formerly Boston Street, in Edward Everett Square in Dorchester. The Queen Anne–style rounded bay apartment building in the center was designed by James H. Besarick and built in 1886 at the corner of Blue Hill Avenue and Alaska Street. (Courtesy of Frank Cheney.)

Seen in 1931, this length of Blue Hill Avenue had three deckers, shops, and storefronts lining both sides of the street. Streetcar No. 5875 travels west through a densely settled neighborhood. (Courtesy of Frank Cheney.)

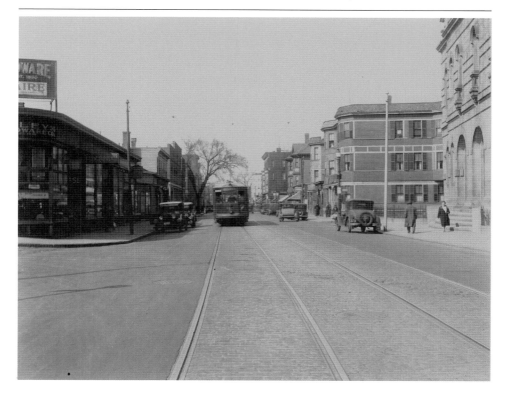

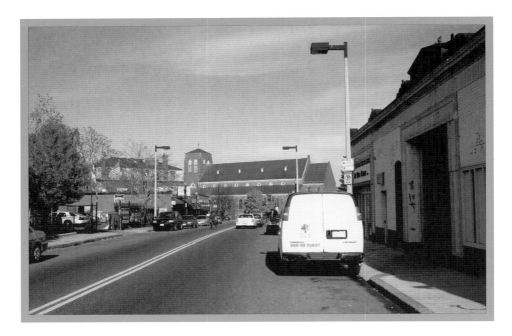

Streetcar No. 5886 is seen on Blue Hill Avenue near Dudley Street in 1947. In the distance is St. Patrick's Church, which was founded in 1872. The church was built at the junction of Dudley and Dunmore Streets, opposite Blue Hill Avenue, and is the third Roman Catholic parish in Roxbury. (Courtesy of Frank Cheney.)

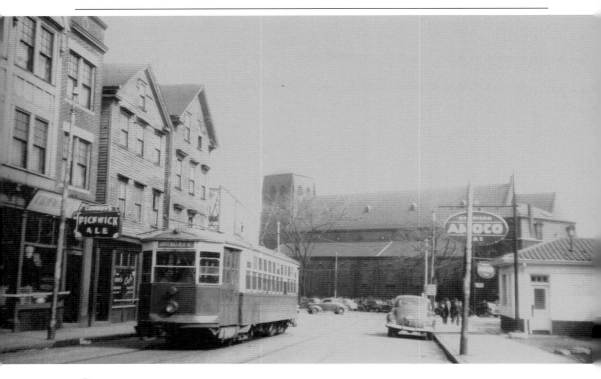

GROVE HALL, ALONG THE AVENUE

ALONG WARREN STREET

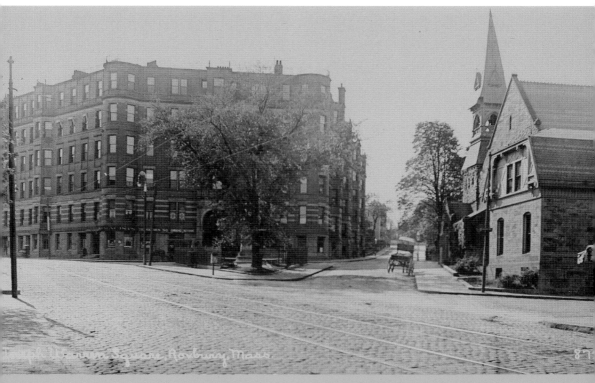

The Warren was a six-story apartment building that commanded Joseph Warren Square, the junction of Warren, St. James, and Regent Streets. Obscured by a tree is the statue of Joseph Warren, sculpted in Paris by Paul Wayland Bartlett (1865–1925) and erected in 1904. Built of redbrick with limestone stringcourses, the Warren was the home of professionals, young married couples, and affluent senior citizens. On the right is the Church of the New Jerusalem at the corner of St. James Street. (Author's collection.)

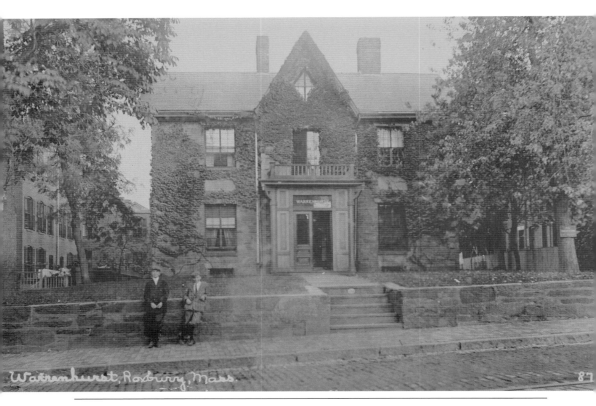

Warrenhurst, Roxbury, Mass.

87

The Warrenhurst is a Gothic Revival cottage built in 1846 by the Warren family at 130 Warren Street, near Winthrop Street, on the site of their ancestral family home. Built of Roxbury puddingstone, a plaque on the house states that "on this spot stood the house erected in 1720 by Joseph Warren of Boston, remarkable for being the birthplace of General Joseph Warren, his grandson who was killed at the battle of Bunker Hill, June 17, 1775." (Author's collection.)

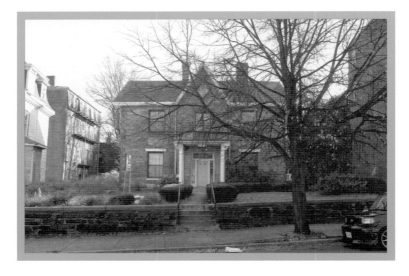

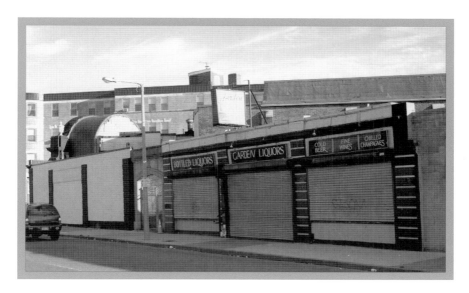

Dr. George Goldings Kennedy (1841–1918) was a noted physician, having graduated from Harvard and the Harvard Medical School, who lived at 284 Warren Street. His father, Dr. Donald Kennedy, had concocted the famous "Kennedy's Medical Discovery," an elixir that supposedly cured every ache and pain with a spoonful of the alcohol-based medicine. Dr. Kennedy later built The Pines, a mansion at Blue Hill Avenue and Brush Hill Road in Milton, which is today known as Fuller Village. (Courtesy of Boston Public Library.)

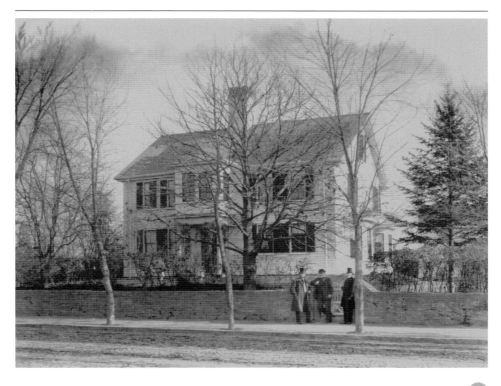

The Stone Store was built around 1850, at the junction of Warren Street and Walnut Avenue, completely of Roxbury puddingstone. The Italianate arches along the first floor had shops such as Peter A. Riley Plumbing Shop and the Warren Apothecary and soda shop on the corner. Above was Highland Hall, a large public meeting space that was named as the town was known, Boston Highlands, in the late 19th century. On the far left can be seen the clock tower of the Roxbury High School at the corner of Warren and Montrose Streets. (Courtesy of Historic New England.)

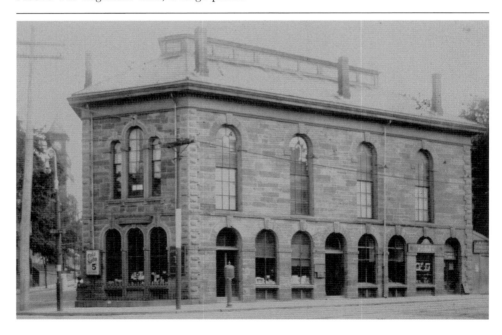

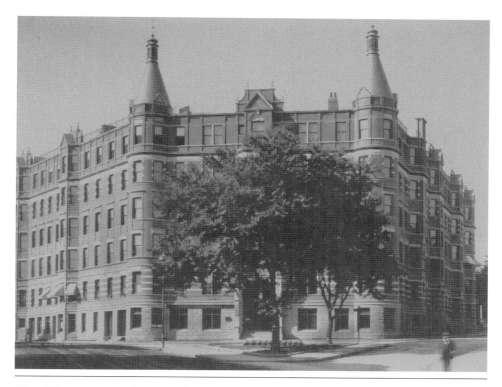

The Warren was a fashionable six-story apartment building that cantilevered between Warren and Regent Streets and faced Joseph Warren Square. Notice the row of cannons on the triangular grass lot in front, relics of the American Revolution. The redbrick and limestone stringcourses along with rounded bays capped with pinnacled roofs and projecting bays made this large apartment building a popular and feasible alternative to large single family houses. (Courtesy of Boston Public Library.)

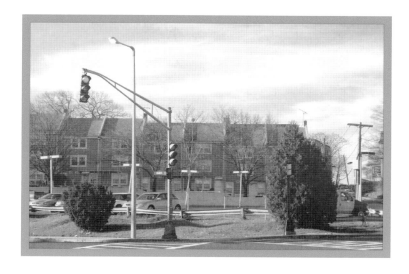

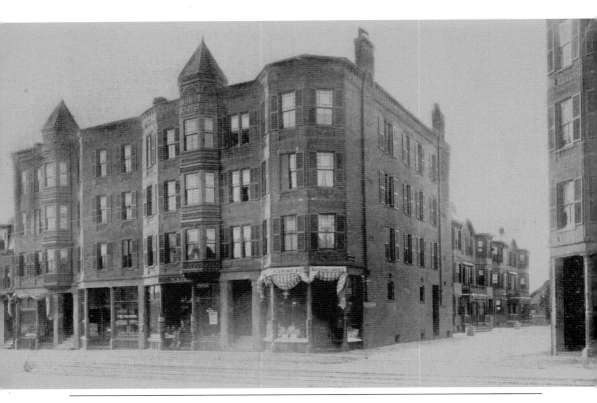

Some of the apartment buildings along Warren Street were small in comparison to the Warren. The Hotel Hurd (four units at 319 Warren Street), the Hotel Margaret (six units at 325 Warren Street), and the Hotel Mabel (three units at 331 Warren Street) were typical of the redbrick, multi-family blocks built in the late 19th century with shops on the first floor. (Courtesy of William Dillon.)

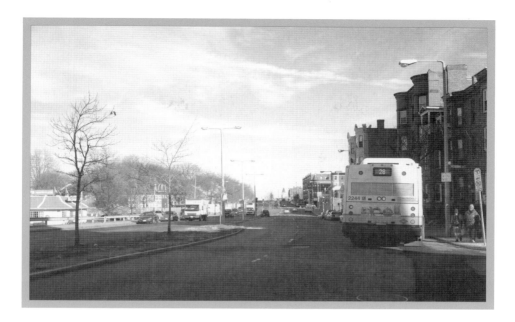

The junction of Warren and Woodbine Streets, seen in 1949, had redbrick three- and four-story apartment blocks lining both sides of the street. Woodbine Street was laid out in 1870 from Warren Street to Blue Hill Avenue. In the center distance the tower of the Roxbury High School at the corner of Montrose Street, where streetcar No. 5932 proceeds toward Grove Hall, can be seen. (Courtesy of Frank Cheney.)

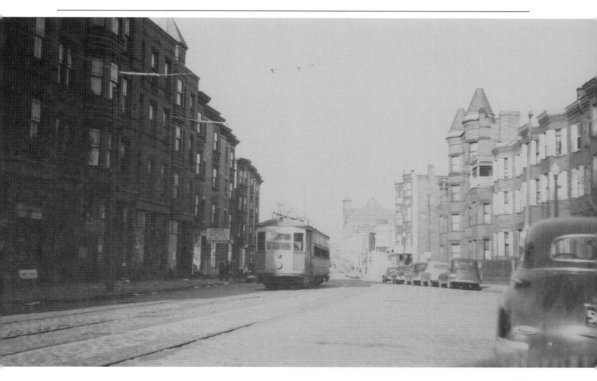

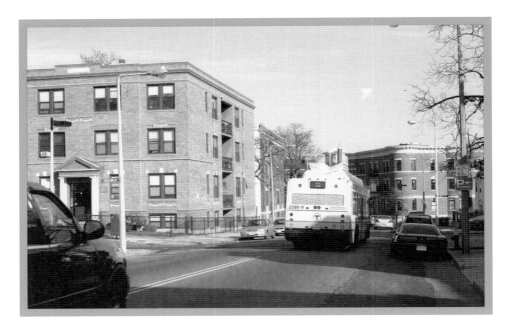

Streetcar No. 6554 travels along Warren Street, with 1 Howland Street on the left, in 1948. Howland Street was laid out in 1880 from Warren Street to Humboldt Avenue. The elegant redbrick and concrete, three-story Colonial Revival apartment building on the left was typical of what was being built in the 1925–1940 period throughout Roxbury for the burgeoning community. (Courtesy of Frank Cheney.)

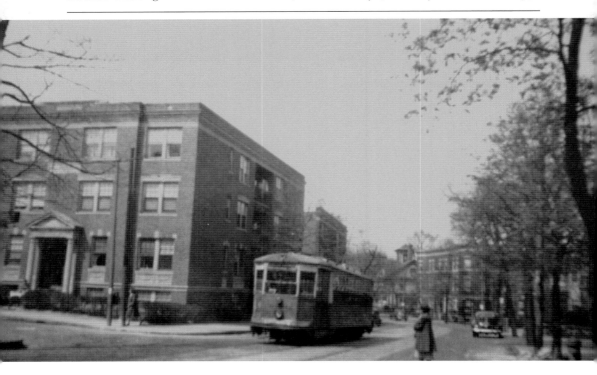

ALONG DUDLEY STREET

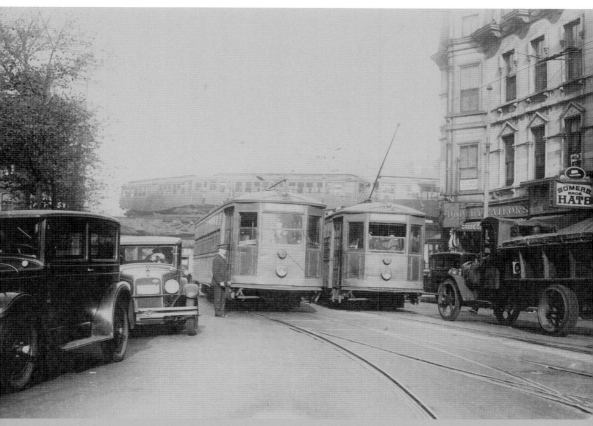

Considered the "Busiest Switch" in Boston, the junction of Dudley and Warren Streets in 1926 has streetcars No. 5606 and No. 5688 side by side in front of the Hotel Dartmouth. Once known as Dove's Corners in honor of William Dove, a local merchant, it still is a busy intersection. Notice the Dudley Tailors and the Somers Brothers Hat Shop in the Hotel Dartmouth. In the distance an elevated train can be seen curving along the tracks as it pulls into Dudley Street Station. (Courtesy of Frank Cheney.)

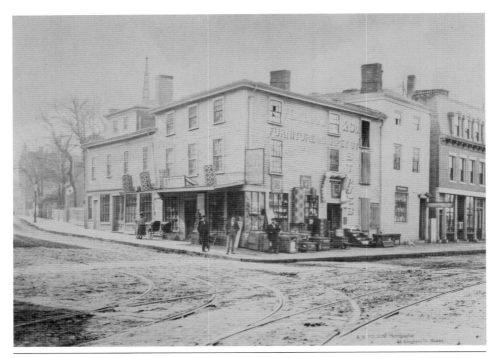

Ferdinand and Company was founded in 1865 at the corner of Washington and Warren Streets and was originally located in an early-19th-century house, which was converted to a store for furniture, carpets, and stoves. In 1895, architect John Lyman Faxon (1851–1918) designed an impressive five-story Baroque and Renaissance Revival store on the site, which was promptly called Ferdinand's Blue Store, with large plate glass display windows both on the facade as well as adjacent to the platform of Dudley Street Station. (Courtesy of Historic New England.)

Octagon Hall was built by Nathaniel Dorr at the junction of Dudley and Kenilworth Streets, opposite the Roxbury Town-City Hall. Built in 1826 as an octagon of quarried ledge stone, the eight-sided building had a squat square tower entrance flanked by huge lancet-shaped windows. Later used as the Norfolk Bank, the first institution of its kind in Roxbury, it also served as the headquarters of the Roxbury Gas Light Company. (Author's collection.)

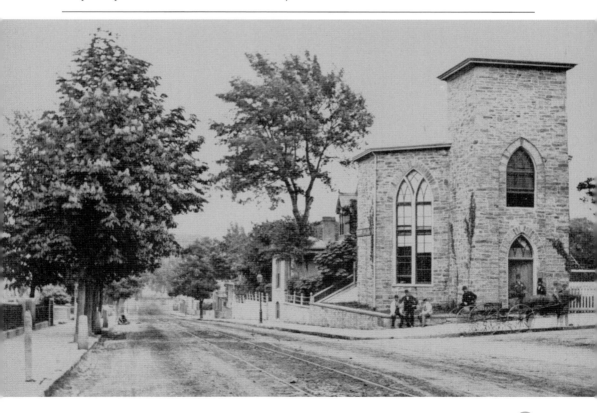

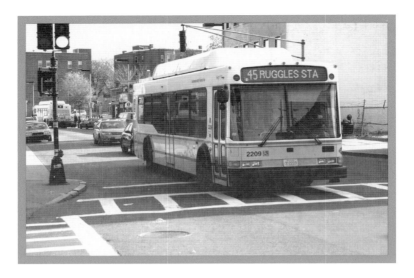

A starter stands beside streetcar No. 5891 at Dudley Street in 1926. This streetcar was known as a Type 5 car, which was used in Roxbury from 1922 to 1949. The signal station above Washington Street on the Elevated Railway can be seen in the distance. The last train on the Elevated Railway was in 1987, and since 2002, the Silver Line has provided bus service along Washington Street. (Courtesy of Frank Cheney.)

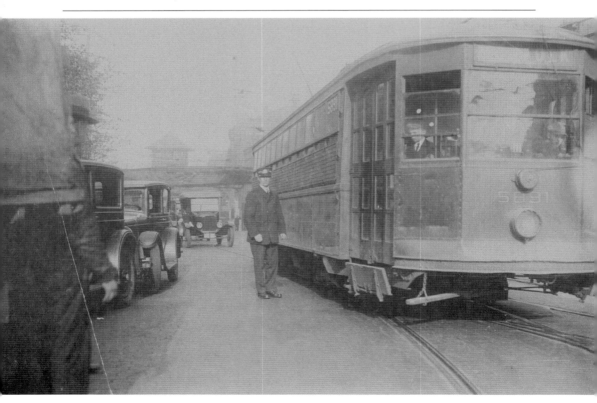

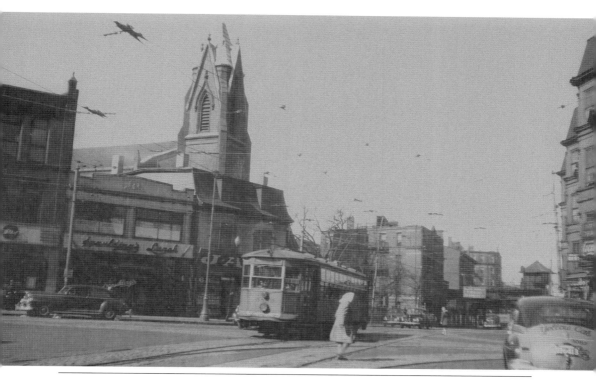

Streetcar No. 5880 approaches the junction of Dudley and Warren Streets in 1947 with the spire of the Dudley Street Baptist Church rising prominently above. This area was one of the busiest areas in Roxbury, with shops, stores, and even a Waldorf Cafeteria and a Spaulding Cafeteria side by side, both sharing in the high foot traffic of the area around Dudley Square. (Courtesy of Frank Cheney.)

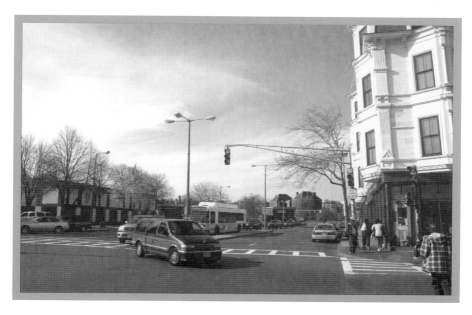

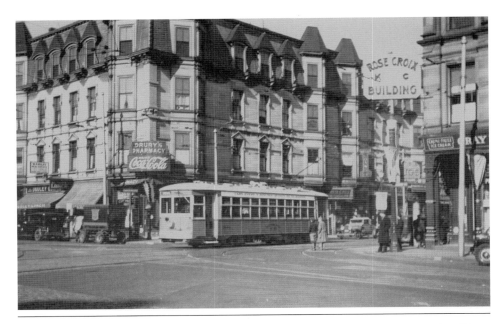

Streetcar No. 7043 approaches the junction of Dudley and Warren Streets in 1938. On the left is the Hotel Dartmouth, an apartment building designed by John Roulestone Hall and built in 1871. Notice the Dudley Lunch, Drury's Pharmacy, and the Miles Real Estate Office. On the right, with a sign stating the "Rose Croix Knights of Columbus Building," is a corner of Palladio Hall, designed in 1877 by Nathaniel J. Bradlee, and built of Ohio sandstone in the Renaissance style with a cast iron storefront. (Courtesy of Frank Cheney.)

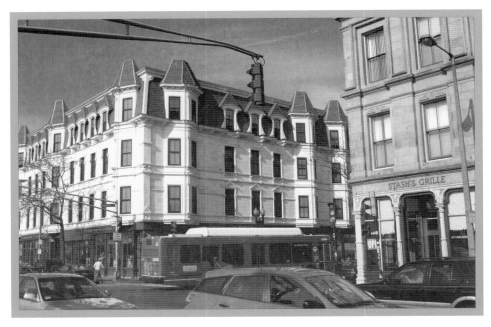

Looking down Dudley Street toward Washington Street in 1936, the well known Rivoli Theatre can be seen on the left, which was advertising the movie *Tank* *at Oxford* on its marquee. The Rockland National Bank can be seen in the center, just past the Boston Elevated Railway tracks. (Courtesy of Frank Cheney.)

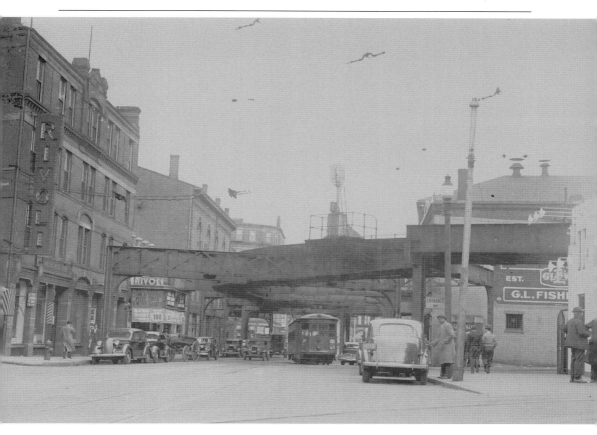

Streetcar No. 5560 leaves Dudley Station in 1938, entering Warren Street, which was a major connector street to all parts of Roxbury. Next to the station is the annex of Ferdinand's Blue Store, a fashionable furniture store and local landmark. The Elevated Railway was to be extended in 1909 to Forest Hills, although Dudley Station remained a busy transfer point for streetcars and later buses. (Courtesy of Frank Cheney.)

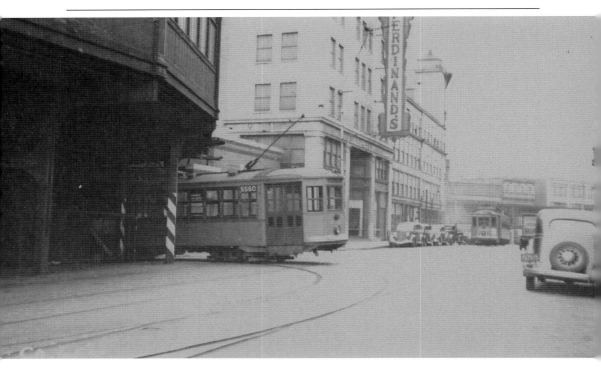

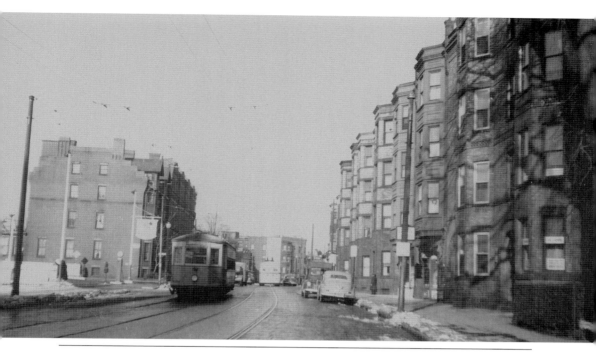

Streetcar No. 5592 is at the intersection of Dudley and Burgess Streets in 1948. Burgess Street was laid out in 1888 from Dudley Street to Clifton Street. (Courtesy of Frank Cheney.)

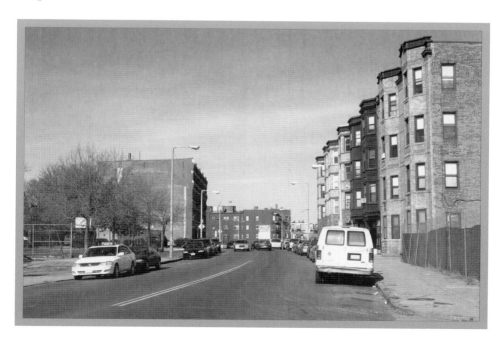

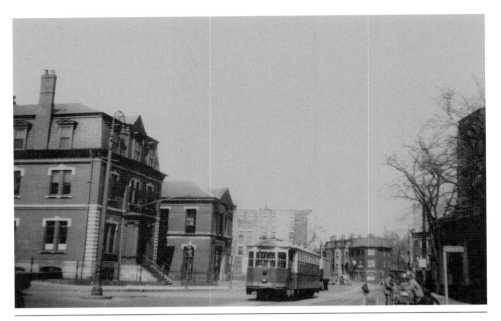

Streetcar No. 5893 approaches the major intersection of Dudley Street and Blue Hill Avenue in 1947. The police and fire station can be seen on the left, side by side where they provided protection for the neighborhood; today La Alianza Hispana is located in the former police station. On the right is the tower of St. Patrick's Church at the junction of Dudley and Dunmore Streets. (Courtesy of Frank Cheney.)

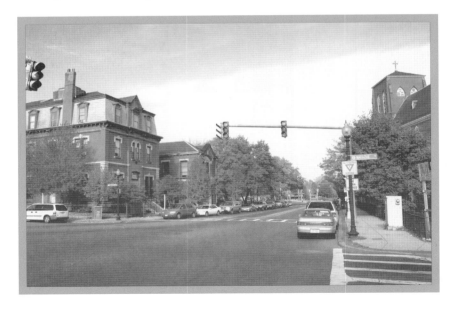

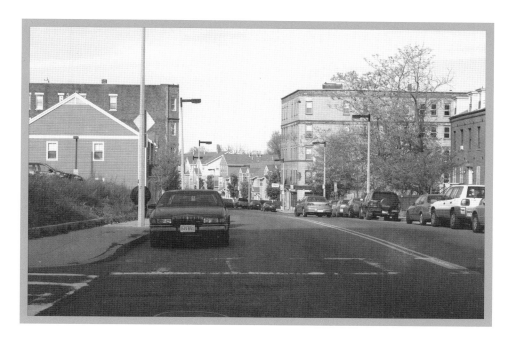

Streetcar No. 5592 approaches the intersection of Dudley and Vine Streets in 1948 headed towards Upham's Corner in Dorchester. Vine Street was laid out in 1851 from Dudley Street to Mount Pleasant Avenue. On the right, just past the Greek Revival house, are 318 and 320 Dudley Street, a *c.* 1840 redbrick duplex. (Courtesy of Frank Cheney.)

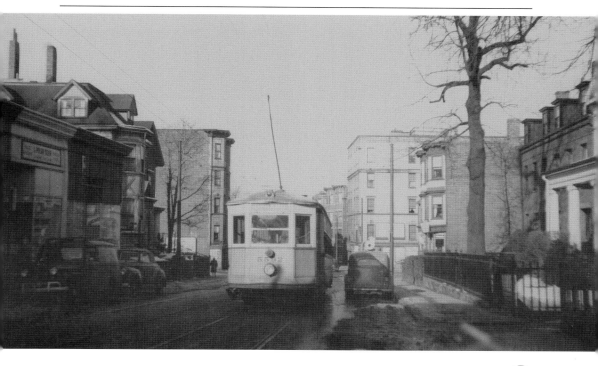

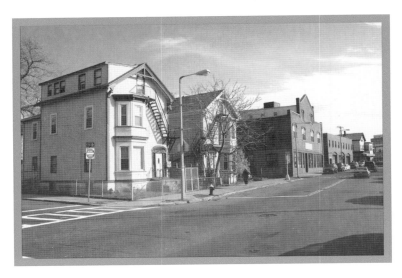

Open car No. 2354 is seen in 1907 on Dudley Street near Shirley Street passing the former Mount Pleasant Street Car House, which was built in 1864 for horsecars and a horse stable. A former drive to the Shirley-Eustis House, Shirley Street was laid out in 1886. The streetcar was bound from Field's Corner via Meeting House Hill in Dorchester to Dudley Station, Norfolk House, and then to Roxbury Crossing. (Courtesy of Frank Cheney.)

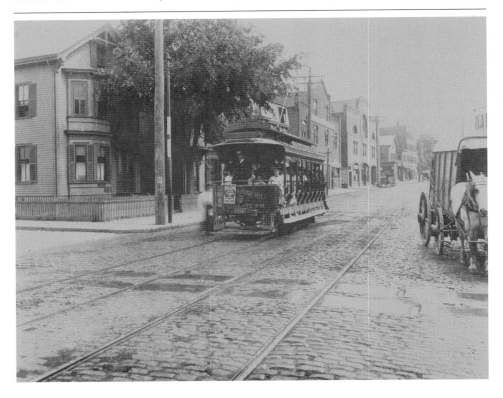

ROXBURY RESIDENCES

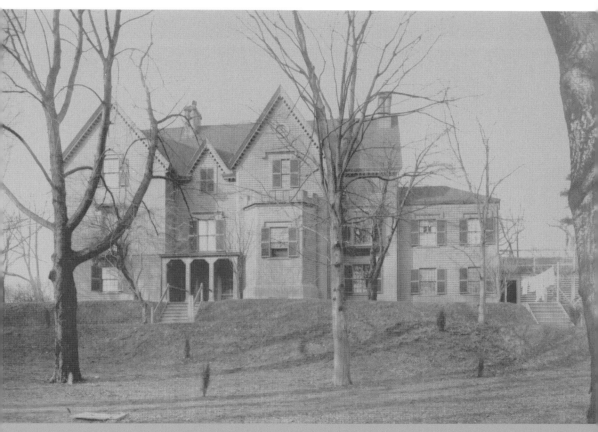

Bromley Vale was the 14 acre country estate of the illustrious Lowell family. John Amory Lowell (1798–1881) was a wealthy merchant, fellow of Harvard College, trustee of the Lowell Institute, and maintained an extensive farm in Roxbury where he experimented in horticulture as a gentleman farmer. The last family member to live on the estate was Anna Cabot Lowell, after which the estate was subdivided and a portion used for the Bromley Heath Housing Development, begun in 1952 and designed by Thomas F. McDonough. (Courtesy of Historic New England.)

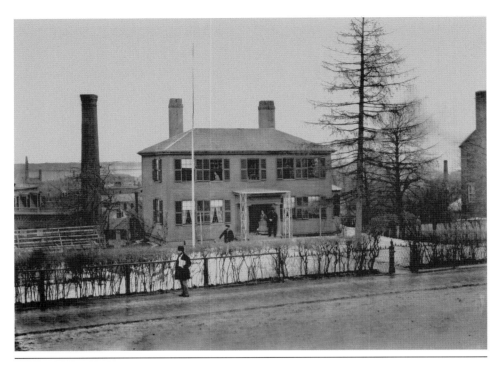

The Prang House was an early-19th-century Federal house at 45 Centre Street. It was the home of Louis Prang (1824–1909), a German immigrant who fled Germany in the 1848 revolution. Living with his in-laws the Heinzens, it was adjacent to his chromolithography factory which he opened at Roxbury and Gardner Streets in 1856. Seen on the far left is the factory and chimney where Prang printed and introduced the first Christmas cards in this country in 1875. Today a large mansion he built near his earlier home stands adjacent to the site and is known as the Prang House, and new housing has been built adjacent. (Courtesy of Historic New England.)

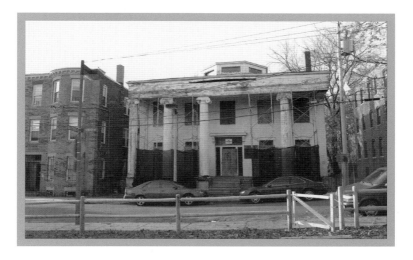

The Kittredge-Bradlee House was built in 1836 by Alvah Kittredge and set on an extensive estate on Fort Hill. An impressive Greek Revival mansion, it had six monumental Ionic columns that supported a pediment as well as an octagonal oculus surmounting the roof. The estate was purchased in 1866 by noted architect Nathaniel J. Bradlee. Once located on Highland Street, the mansion was moved to 10 Linwood Street where it is today owned by the Roxbury Action Program, and its restoration is anxiously awaited. (Courtesy of Jean Reed Emmons Bullock.)

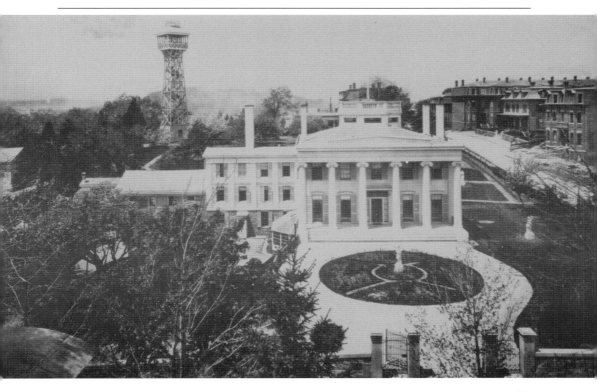

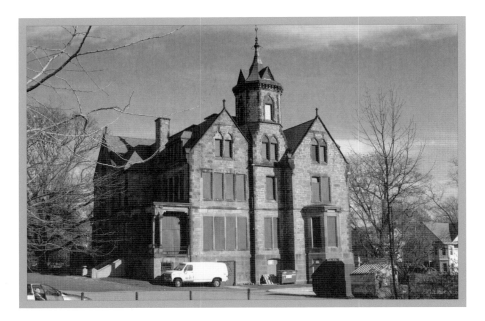

Abbotsford was designed by Boston architect Alden Frick, and built in 1872 of the prevalent Roxbury puddingstone that still dots the landscape. Built for Aaron Davis Williams Jr. (1821–1899), a prominent industrialist and president of the Boston Lead Company, this impressive Gothic inspired mansion retains its prominent site, part of which was once extensive apple orchards, and grounds, which were once magnificently landscaped. The mansion was later the annex of the Ellis School, and since 1976, has been the Museum of the National Center of Afro-American Artists. (Courtesy of Historic New England.)

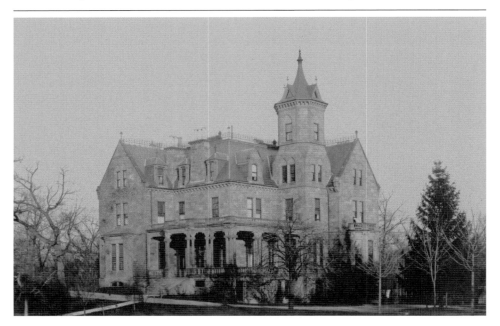

ROXBURY RESIDENCES

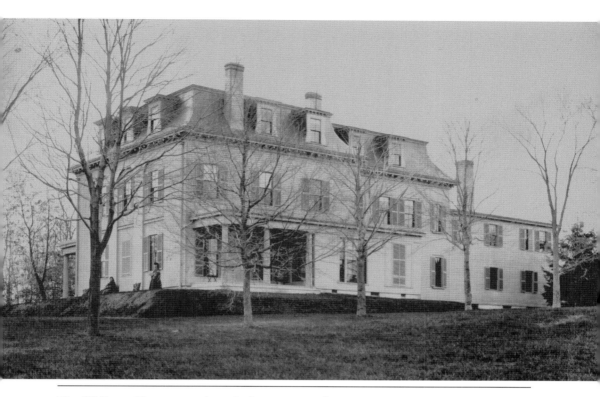

The Williams House was a large Italianate mansion with a prominent mansard roof at 445 Warren Street, between Deckard and Townsend Streets. The extensive estate was later developed as the site of the Roxbury Memorial High School, which was subsequently the Boston Technical High School and is today the Boston Latin Academy. (Courtesy of Historic New England.)

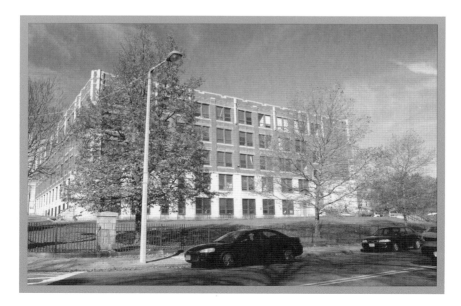

The Thwing House was a large mansion with a mansard roof and tower at 175 Highland Street on Fort Hill. Seen in 1865, members of the family include Supply Clap Thwing (1798–1877) in front of the wall, and on the front stairs are his wife, son Walter Eliot Thwing, and daughter Annie Haven Thwing. Walter wrote the *History of the First Church in Roxbury* and Annie wrote *The Crooked and Narrow Streets of Boston.* (Courtesy of Historic New England.)

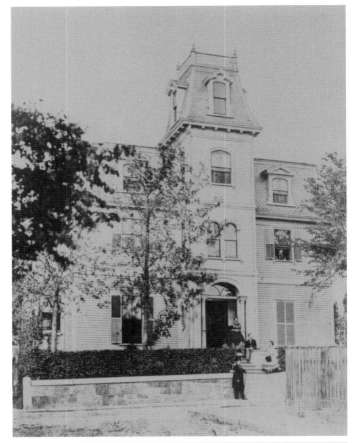

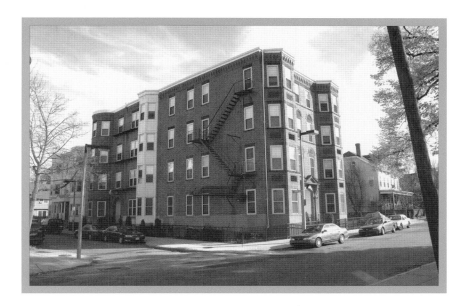

The Hotel Park was at 101 Dale Street and was built in 1884 as an eight unit apartment house. In the late 19th century, Roxbury was called Boston Highlands and became a densely populated neighborhood of the city, with numerous apartment buildings. On the right is the home of Bartholomew J. Connolly at 93 Dale Street. The fancy apartment building on the left is the Regent, at the corner of Regent and Hewes Streets. (Courtesy of Historic New England.)

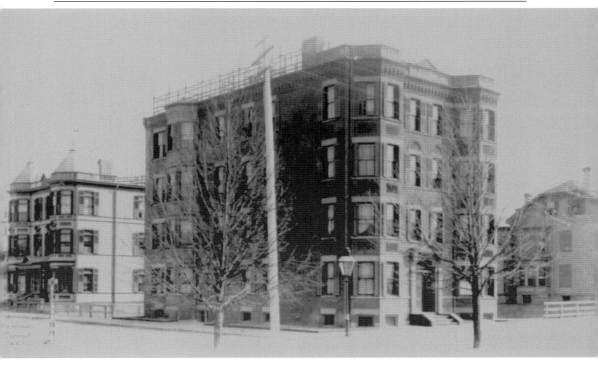

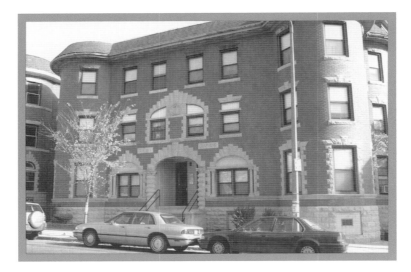

The Elm Hill Chambers is at the corner of Warren Street and Elm Hill Park. A center entrance apartment building of redbrick and hammered-granite trim and foundation, the rounded bays on either side create an impressive block. Another apartment building of the same design is adjacent at 538–544 Warren Street, and two others are on the opposite side of Elm Hill Park at 546–552 Warren Street. (Courtesy of Historic New England.)

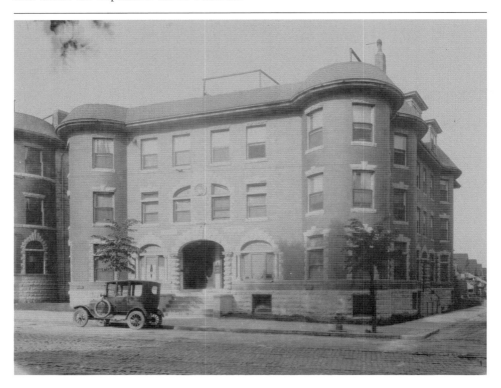

CHAPTER 8

ALL MODES
OF TRANSPORTATION

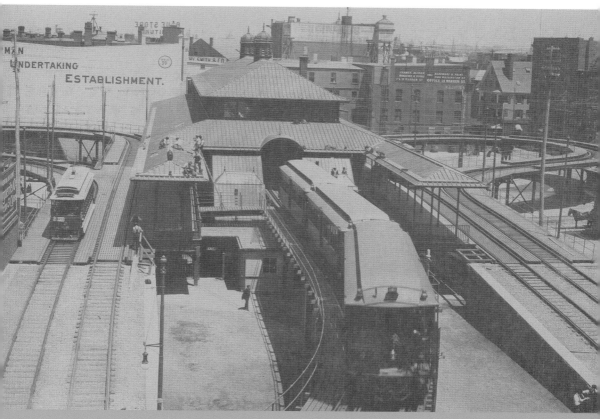

Dudley Street Station was opened in 1901 and was originally the terminus on the Elevated Railway that extended through the city to Sullivan Square in Charlestown. Designed by Alexander Wadsworth Longfellow (1854–1943), Dudley Street Station had impressive leaded glass windows, copper roofs, and platforms. Seen here on June 11, 1901 (the second day of operation), the trolley loop on the left served cars going to Roxbury Crossing, Jamaica Plain, and Brookline, while the loop on the right served cars for Grove Hall, Mattapan, and Neponset. (Courtesy of Frank Cheney.)

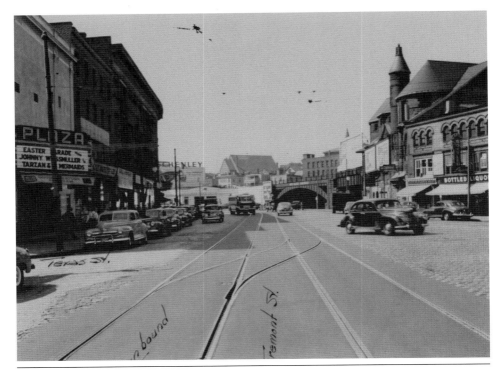

Roxbury Crossing, seen here in 1948 at the intersection of Tremont and Texas Streets, had a passenger station on the Boston and Providence Railroad (later the New York, New Haven and Hartford) Line. Texas Street was laid out in 1886 between Tremont and Elmwood Streets. The turreted redbrick and brownstone station was designed by John Calvin Spofford in the area once known as Pierpont's Village, now known as Roxbury Crossing. On the left at the corner of Texas Street is the Plaza Theatre, which was advertising the now famous *Easter Parade*, *Tarzan*, and *Mermaid* on its marquee. (Courtesy of Historic New England.)

ALL MODES OF TRANSPORTATION

In January 1900, the Elevated Railway was under construction over Washington Street, the former Neck that connected Boston to the mainland. Here at the junction of Washington and Eustis Streets, with the steel girders that support the railway bed, it is being extended towards what will be Dudley Street Station, the terminus on the line. On the left 2121 Washington Street can be seen, and the streetcar on the right is an East Boston and Chelsea streetcar. (Courtesy of Frank Cheney.)

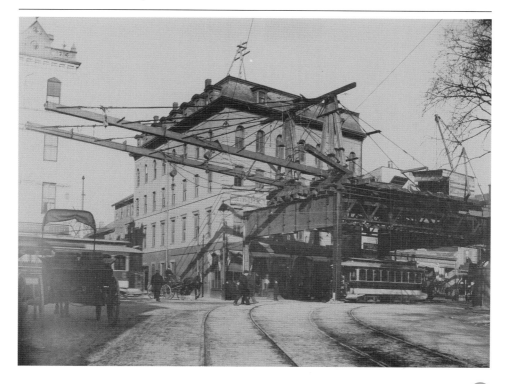

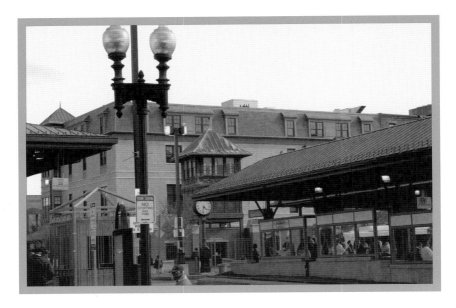

Dudley Square, seen in March 1901, was dominated by a switching station on the Elevated Railway high above the intersection of Washington and Dudley Streets. On the left is the rounded redbrick Dudley Block, built in 1852. Notice the cobblestone streets and the flat granite blocks serving as pedestrian walkways. (Courtesy of Frank Cheney.)

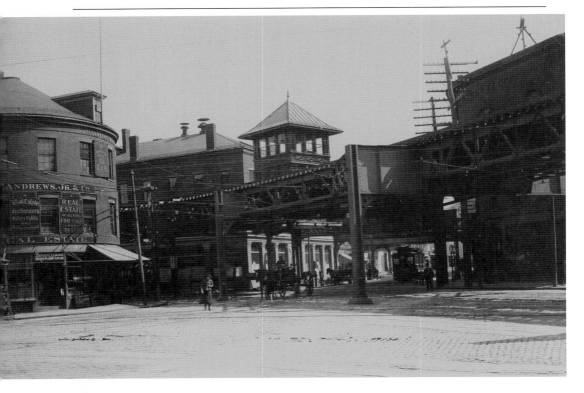

ALL MODES OF TRANSPORTATION

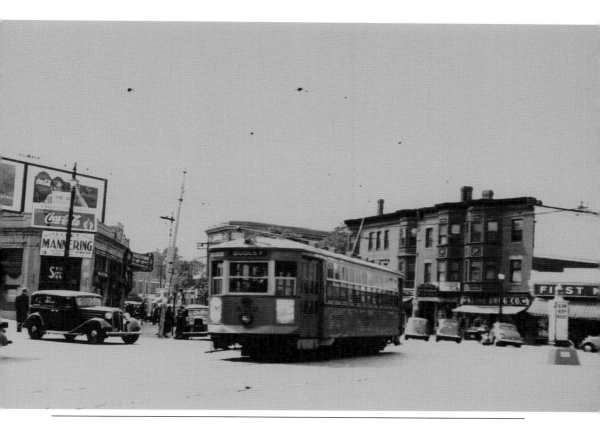

Brigham Circle is the junction of Huntington and Francis Avenues and Tremont Street, and since 1913 has been the prominent site of the colonnaded Peter Bent Brigham Hospital, designed by Codman and Espadrille. Here in 1938, streetcar No 5712 turns onto Tremont Street headed towards Mission Hill, which then continued on to Dudley Station. Notice the traffic stanchion on the right cautioning motorists to keep slow and to its right. (Author's collection.)

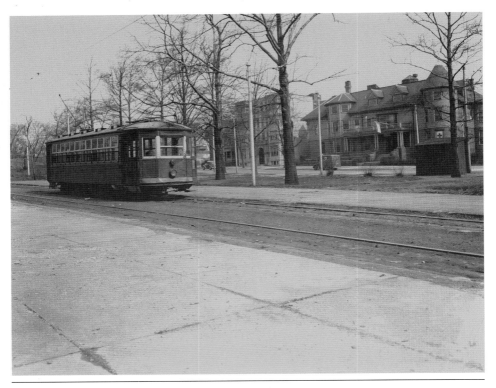

Streetcar No. 5711, a Type 5 car, is at the Seaver Street Loop in April 1944. It was named for Ebenezer Seaver (1763–1844), who was a member of the U.S. Congress and a representative. His estate was known as the Long Crouch and was opposite Elm Hill Avenue. The large mansion on the right, at 108 Seaver Street, was built by Simon Goldsmith and later became the Young Men's Hebrew Association (YMHA) that moved here in 1911 from the South End and was a prominent institution until 1960 when the property was sold to the Berea Seventh Day Adventist Church. (Courtesy of Frank Cheney.)

Trackless trolleys No. 8478 and No. 8473 are pulling up to the side of The Warren at the corner of St. James and Regent Streets at Joseph Warren Square in February 1949. Trolley buses replaced most streetcars on nine transportation lines in the Roxbury and Dorchester area between 1948 and 1949. Diesel buses would replace the trolley buses on these routes in April 1962. On the right is the Church of New Jerusalem, later the Church of God in Christ. (Courtesy of Frank Cheney.)

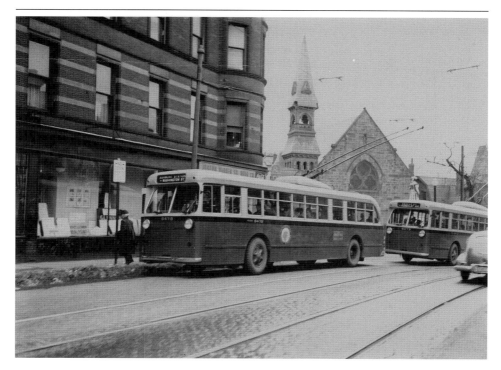

ACROSS AMERICA, PEOPLE ARE DISCOVERING SOMETHING WONDERFUL. *THEIR HERITAGE.*

Arcadia Publishing is the leading local history publisher in the United States. With more than 3,000 titles in print and hundreds of new titles released every year, Arcadia has extensive specialized experience chronicling the history of communities and celebrating America's hidden stories, bringing to life the people, places, and events from the past. To discover the history of other communities across the nation, please visit:

www.arcadiapublishing.com

Customized search tools allow you to find regional history books about the town where you grew up, the cities where your friends and family live, the town where your parents met, or even that retirement spot you've been dreaming about.